dateline:Israel

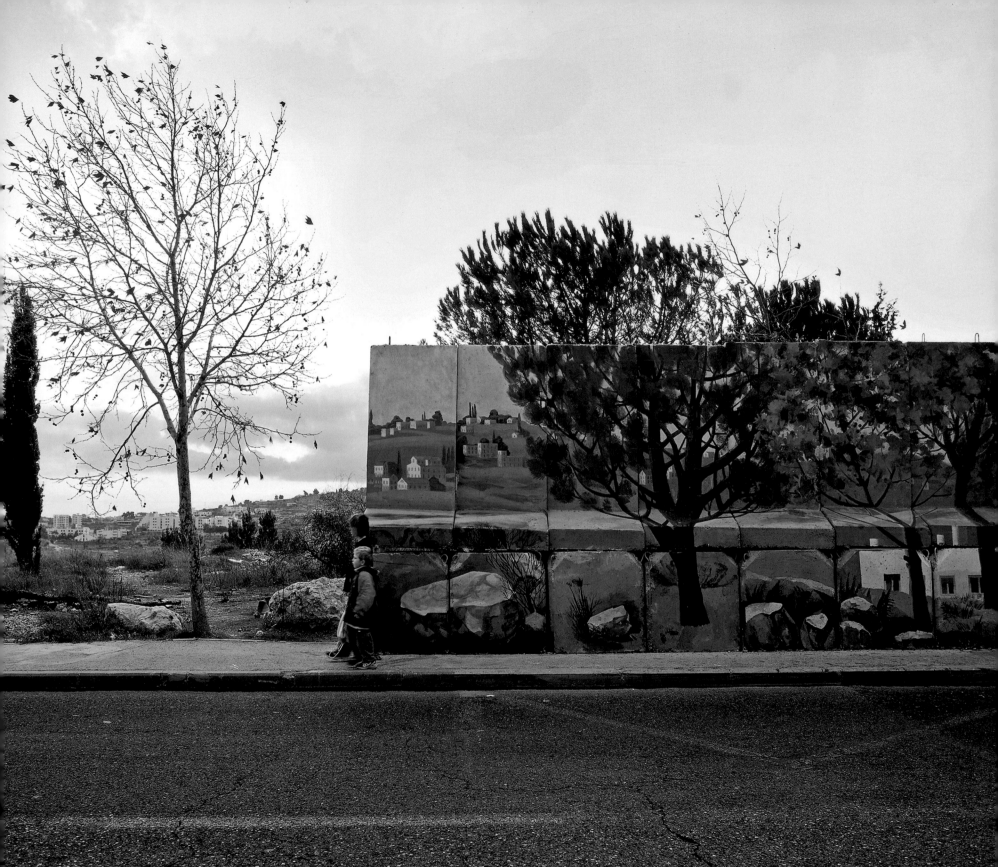

dateline:Israel

New Photography and Video Art

Susan Tumarkin Goodman

With essays by
Andy Grundberg
Nissan N. Perez

The Jewish Museum, New York
Under the auspices of the Jewish Theological Seminary of America

Yale University Press
New Haven and London

This book has been published in conjunction with the exhibition **Dateline Israel: New Photography and Video Art**, organized by The Jewish Museum and presented from March 10 to August 5, 2007.

The Jewish Museum
Exhibition Curator: Susan Tumarkin Goodman
Manager of Curatorial Publications: Michael Sittenfeld
Exhibition Assistants: Afshaan Rahman and Alyssa Phoebus
Manuscript Editor: Joseph N. Newland, Q.E.D.

Exhibition Design: Daniel Bradley Kershaw
Exhibition Graphic Design: Steven Schoenfelder

Yale University Press
Publisher, Art and Architecture: Patricia Fidler
Editor, Art and Architecture: Michelle Komie
Manuscript Editor: Heidi Downey
Production Manager: Mary Mayer
Photo Editor: John Long

Designed by Steven Schoenfelder
Typeset in Avenir, Din, & Caecilia
Printed in Singapore by CS Graphics

The Jewish Museum
1109 Fifth Avenue
New York, New York 10128
www.thejewishmuseum.org

Yale University Press
P.O. Box 209040
New Haven, Connecticut 06520-9040
yalebooks.com

Library of Congress Cataloging-in-Publication Data

Dateline Israel : new photography and video art / edited by Susan Tumarkin Goodman ; with essays by Susan Tumarkin Goodman, Andy Grundberg, Nissan N. Perez.
 p. cm.
Catalog of an exhibition of the same name organized by The Jewish Museum and presented from March 10 to August 5, 2007.
 Includes bibliographical references and index.
 ISBN 978-0-300-11156-9 (cloth : alk. paper)
 1. Photography, Artistic—Exhibitions. 2. Photography—Israel—Exhibitions. 3. Video art—Israel—Exhibitions. I. Goodman, Susan Tumarkin. II. Grundberg, Andy. III. Perez, Nissan. IV. Jewish Museum (New York, N.Y.)
 TR646.I76D38 2007
 779.095694'0747471—dc22
 2006025335

A catalogue record for this book is available from the British Library. The paper in this book meets the guidelines for permanence and durability of the Committee on Production Guidelines for Book Longevity of the Council on Library Resources

10 9 8 7 6 5 4 3 2 1

COVER ILLUSTRATIONS: *(front)* Wolfgang Tillmans, *Aufsicht (yellow)* (detail of pl. 1); (back, from left) Rineke Dijkstra, *Abigail, Herzliya, Israel, April 10, 1999* (p. 15, fig. 18), and Rineke Dijkstra, *Abigail, Palmahim Israeli Air Force Base, December 18, 2000* (p. 15, fig. 19)
ENDLEAVES: Yael Bartana, *Trembling Time* (detail of pl. 12)
FRONTISPIECE: Shai Kremer, *Defense Wall surrounding Gilo neighborhood, Jerusalem 2004* (detail of fig. 11, p. 31)
P. IV: Guy Raz, *Lifeguard Towers–Serial 1* (detail of pl. 7)
PP. VI-VII: Catherine Yass, *Wall, 2004* (detail)

contents

Donors to the Exhibition

Dateline Israel: New Photography and Video Art was made possible by a leadership grant from the Andrea & Charles Bronfman Philanthropies and through endowed funds from the Melva Bucksbaum Fund for Contemporary Art.

Additional support was provided by the Alfred J. Grunebaum Memorial Fund and Israel National Lottery Council for the Arts. Transportation assistance was provided by EL AL Israel Airlines.

Lenders to the Exhibition

Nelly Aman Gallery, Tel Aviv

Boaz Arad and Miki Kratsman, Tel Aviv

Bonni Benrubi Gallery, New York

Chelouche Gallery, Tel Aviv

Dvir Gallery, Tel Aviv

Galerie Krinzinger, Vienna

Annet Gelink Gallery, Amsterdam

Marian Goodman Gallery, New York

Amit Goren, Tel Aviv

Herzliya Museum of Contemporary Art, Tel Aviv

The Israel Museum, Jerusalem

Alison Jacques Gallery, London

Thomas H. Lee and Ann Tenenbaum, New York

Yaron Leshem, New York

Lisson Gallery, London

Loushy Art & Editions, Tel Aviv

Andrea Meislin Gallery, New York

Ruth O'Hara Gallery, New York

Judy and Don Rechler, Locust Valley, New York

Andrea Rosen Gallery, New York

Julie Saul Gallery, New York

Foreword

The Jewish Museum has had a long-standing commitment to both collecting and exhibiting art related to Israel. While our emphasis has been primarily on works by Israeli artists, the museum has increasingly turned its focus to Israel as subject, regardless of an artist's place of birth. *Dateline Israel: New Photography and Video Art* affords us an opportunity to consider a country as seen by native and foreign contemporary artists when it continues to struggle with internal and external challenges.

All three writers in this exhibition catalogue refer to "lens-based" art, a term they use to encompass the mediums of photography, film, and video. The word "lens" serves as a useful metaphor as well for the entire exhibition, which presents the varying perspectives of the artists, the curator, and the essayists. Yet an additional lens, perhaps wide-angle, is the larger context of The Jewish Museum itself, within which is a permanent exhibition that traces the history of the Jewish people to the ancient land of Israel. Thus lenses, literally and figuratively, mediate our understanding of *Dateline Israel.*

Three earlier Jewish Museum exhibitions, mounted at approximately ten-year intervals, may be seen as precursors to *Dateline Israel.* Together, they show a shift in medium and message and reflect the emergence of Israeli artists into an international arena—an arena that has seen a flow of artists, curators, dealers, and collectors across national borders.

Artists of Israel: 1920–1980, presented in 1981, was a retrospective look, one of the first in this country to introduce the American public to a little-known group of Israeli artists whose work, ranging in style from abstraction to realism, had a tangible connection to their native land. However diverse in style, the art had in many respects a unifying "message": it celebrated freedom of expression and the creation of a new Israeli culture, regardless of whether it carried on a European modernist tradition or depicted the country's unique landscape and people.

Nine years later, *In the Shadow of Conflict: Israeli Art, 1980–1989* focused on a group of contemporary artists—again creating painting and sculpture, though some with mixed media—who, in the words of curator Susan Tumarkin Goodman, reflected the "insistent use in art of iconography reflecting the escalating political, social, and religious confrontations in Israel." In his catalogue essay, A. B. Yehoshua offered yet another interpretation, saying that Israeli culture after 1977 lacked a clear identity because of a "disintegration of the national center." Consequently, questions about what it meant to be Israeli were the themes of art, literature, and music of the period.

A decade later, *After Rabin: New Art from Israel,* mounted on the fiftieth anniversary of the State of Israel, suggested a further change in Israeli culture. In her introduction to the exhibition catalogue, Goodman used phrases such as "inner turmoil" and

"struggle for survival" about the group of established and emerging artists whose work covered a three-year period. Many photographic works as well as video pieces were included in a show that spoke of the persistence of war, of the tensions between religious and secular populations, and of the plight of new immigrants. The work was more journalistic than in the prior exhibitions, and was permeated with what was referred to as "the situation."

Dateline Israel not only speaks to the continued and deepened presence of art with political undercurrents but also the engagement of a wider world of artists from outside Israel in the rollercoaster of hope and fear, danger and normalcy that has become a way of life. A world of contradictions emerges in these works, which portray beauty and destruction, history and modernity, domesticity and displacement, repose and turmoil.

Senior Curator Susan Tumarkin Goodman has been responsible for all of the museum's Israeli exhibitions and has had a strong hand in shaping its collection of both Israeli art and art about Israel. She is deeply knowledgeable about her subject, and *Dateline Israel* provides much food for thought. Her work has benefited from the astute interpretations of Andy Grundberg and Nissan N. Perez, one writing from the perspective of an American photography critic and the other as an Israeli curator. And Goodman herself provides essential background for individ-

ual works as well as the goals of this project. My thanks to all three authors for their discerning insights.

Few people connected to The Jewish Museum over the years have been as conscientious in nurturing the art of Israel and its dissemination to a larger world than the late Andrea Bronfman. She was a longtime museum trustee, and her generosity made this exhibition possible. We are tremendously grateful to Andrea and her family for providing the means to continue to present Israel through art.

I am grateful as well to the Melva Bucksbaum Fund for Contemporary Art, the Alfred J. Grunebaum Memorial Fund, the Israel National Lottery Council for the Arts, and EL AL Israel Airlines for their generosity in supporting this project. Finally, I would like to thank The Jewish Museum Board of Trustees for its strong endorsement of *Dateline Israel* as well as past exhibitions about Israeli culture. Projects of this nature would be impossible without the Board of Trustees' indispensable counsel and continued financial support.

Joan Rosenbaum
Helen Goldsmith Menschel Director
The Jewish Museum

Acknowledgments

For decades The Jewish Museum has taken the artistic pulse of Israel by presenting works by its most innovative contemporary artists. *Dateline Israel: New Photography and Video Art* focuses on the years following the seismic changes of 2000, when the world watched the Oslo peace process crumble. The plight of Palestinian refugees and the growth of Israeli settlements in Gaza and the West Bank came into sharper focus, even as terrorist attacks on Israel mounted. As we prepared this catalogue, there was a renewed escalation of hostilities between Israel and Hezbollah in Lebanon. This will undoubtedly lead to new and powerful responses by photographers and video artists. Some artists will feel compelled to document these events in a straightforward manner, while others will employ unconventional methods to capture the unfolding reality and many layers of human experience.

Photographers and video artists are among the first to react to such events, and lens based art, unquestionably a dominant means of expression in the twenty-first century, has become the most powerful medium for mining the day-to-day life of Israelis. Because of their immediacy and their ability to represent society in all its complexity, photography and video capture the raw and often unremitting reality of existence.

Dateline Israel benefits from the rich mingling of Israeli and non-Israeli perspectives. While the artists represented here do not necessarily share a worldview or an aesthetic approach, all have a personal connection with Israel: they either were born there or have had a profound experience in the country itself. One might ask: Does an artist born in Israel see the country with a unique perspective? Do artists from abroad have a more objective viewpoint? This exhibition provides a rare opportunity to see the work of both groups side by side. What emerges in *Dateline Israel* is a remarkable commonality among artists who probe the underlying forces and fundamental issues that confront both Israelis and non-Israelis.

I would like to join Joan Rosenbaum in paying tribute to the late Andrea Bronfman, who was the primary force behind this exhibition. It was her encouragement and enthusiasm that energized us to bring this exhibition to fruition. Her tragic death has meant that she will not be with us to see the superb artworks that were inspired by her beloved Israel.

My gratitude goes to the other catalogue essayists, Andy Grundberg and Nissan N. Perez, for their cogent and insightful contributions. They bring vast knowledge to their subjects. Andy Grundberg has provided a lucid overview that places Israeli photography and video in a broader international context, and Nissan Perez offers an impassioned insider's view of the cultural climate in Israel today.

Detail of pl. 24

In bringing *Dateline Israel* to completion, I am grateful for the commitment and labor of the entire Jewish Museum staff, and for the participation of the artists and generous individuals, institutions, and galleries. Our inclusion of artists from Europe, the United States, and Israel required the cooperation and assistance of colleagues far and wide. Many were extremely gracious with their expertise, offering invaluable advice and suggestions: Tal Ben-Zvi, formerly curator at the Hagar Art Gallery, Jaffa; Sergio Edelsztein, director, Center for Contemporary Art, Tel Aviv; Rafi Gamzou, formerly director of the art department at the Israeli Ministry of Foreign Affairs, Jerusalem; Meira Geyra, artistic director, America-Israel Cultural Foundation, Tel Aviv; Naomi Givon, Givon Art Gallery, Ltd., Tel Aviv; Nahama Gottlib, Noga Gallery of Contemporary Art, Tel Aviv; Dahlia Levin, director and chief curator, Herzliya Museum of Art; Doron Polak, Projective, Givatayim; Andrew Renton, director, Curatorial Program, Goldsmiths College, University of London; Rivka Sakar, managing director, Sotheby's, Tel Aviv; Diana Shoef, Art Management, Tel Aviv; and Irit Mayer Sommer, director, Sommer Contemporary Art, Tel Aviv. I am indebted as well to the following individuals whose assistance was crucial in assembling work for the exhibition and catalogue: Judith Caplan, associate curator of photography, the Israel Museum, Jerusalem; Shifra Intrator, Dvir Gallery, Tel Aviv; Nira Itzhaki,

Chelouche Gallery, Tel Aviv; and Andrea Meislin, Andrea Meislin Gallery, New York. I also appreciate the useful exhibition bibliography compiled by Timna Seligman, associate curator, the Israel Museum, Jerusalem.

Dateline Israel could not have been realized without the initial guidance of Joan Rosenbaum, Helen Goldsmith Menschel Director at The Jewish Museum, whose unwavering leadership and astute judgment sustained this project. The museum's Board of Trustees, particularly the exhibition committee chaired by Joshua Nash and Barbara Horowitz, provided valuable guidance in the planning of this project.

As always, I am exceedingly grateful to the staff of The Jewish Museum. I thank Ruth Beesch, deputy director for program, who oversaw the project and consistently offered indispensable guidance and encouragement. Norman L. Kleeblatt, Susan and Elihu Rose Chief Curator, offered judgment and careful consideration of the issues at hand, which figured importantly in the shaping of this exhibition. Additional organizational assistance and helpful suggestions were provided with great good will by curatorial program assistant Afshaan Rahman and former curatorial program assistant Alyssa Phoebus. I extend my deepest appreciation to Sally Lindenbaum and Yocheved Muffs, who have worked on this project for several years, and to curatorial program associate Beth Turk and curatorial interns Adam Eaker,

Detail of pl. 8

Amanda Elbogen, Yael Levy, and Chana Prus for their contributions to the exhibition and the catalogue.

Michael Sittenfeld, manager of curatorial publications at The Jewish Museum, was essential in bringing the catalogue to completion. His sensitivity to the nuances of the project and his fundamental help on all levels of interpretation encouraged me greatly. He has my deepest thanks, as does Steven Schoenfelder for his inventive and effective design of the book. I also wish to express my gratitude to the staff of Yale University Press, particularly Patricia Fidler, Michelle Komie, Mary Mayer, Heidi Downey, and John Long, and to Joseph Newland, manuscript editor for this project.

Numerous other colleagues at The Jewish Museum have provided significant support for *Dateline Israel,* and I wish to acknowledge them. Jane Rubin, director of collections and exhibitions, along with coordinator of exhibitions Dolores Pukki and assistant registrar Amanda Thompson, efficiently and meticulously arranged for the complicated organization and shipping of outside loans from public and private collections, as well as galleries. My thanks to Dan Kershaw, the exhibition designer, whose professionalism and creativity were instrumental to an innovative installation.

I would also like to thank the following Jewish Museum staff members for their invaluable efforts in the realization of

Dateline Israel: Nelly Silagy Benedek, director of education; Elyse Buxbaum, senior manager, corporate and government relations; Jane Fragner, assistant director of education; Sarah Himmelfarb, associate director of development, institutional giving; Andrew Ingall, assistant curator, National Jewish Archive of Broadcasting and Media; Mason Klein, associate curator; Al Lazarte, director of operations; Karen Levitov, associate curator and curatorial manager; Niger Miles, audiovisual coordinator; Jennifer Mock, public programs coordinator; Grace Rapkin, director of marketing; Anne Scher, director of communications; Katherine Staelin, assistant curator for Web projects; Fred Wasserman, Henry J. Leir Curator; Aviva Weintraub, associate curator; and Alex Wittenberg, communications coordinator.

Finally, I wish to express deep gratitude to my husband, Jerry Goodman, for his encouragement and support as this exhibition and catalogue evolved.

Susan Tumarkin Goodman
Senior Curator

Detail of pl. 20

Just as none of us is outside or beyond geography, none of us is completely free from the struggle over geography. That struggle is complex and interesting because it is not only about soldiers and cannons but also about ideas, about forms, about images and imaginings.

—Edward Said, *Culture and Imperialism*

Beyond Boundaries, Within Borders

Andy Grundberg

Much has been written positing that in the twenty-first century we live in a post-industrial, post-colonial, post-national world, one in which the economic forces of global capitalism have erased many of the traditional differences among countries, peoples, and cultures. The development of a hybrid, homogenized human identity with a world rather than tribal point of view would seem to be a logical outcome of this globalization, but events since the year 2000 have shown that resistance to the loss of longstanding cultural identity, whether ethnic, racial, religious, or tribal, is at once innate and frightening.

As the late cultural critic Edward Said has written, our current situation is mapped on the land, on a struggle over geography in both its literal, territorial meaning and its cultural, social, and political dimensions. One sees this most clearly today in the Middle East, where the American invasion of Iraq, for example, has not only called into question the "post-" in post-colonialism but also sparked a chaotic eruption of intra-Islamic bloodshed. And, of course, one sees it in Israel and its neighbors, where claims and conflicts over borders clash with traditional patterns of settlement and social interaction. But one could also look at the Sudan, where genocide has been waged against the civilian population, and at West Africa, where rival militias enlist children to commit atrocities in rural villages.

What does this mean for art, which increasingly appears as a globalized enterprise in terms of production and consumption? More to the point, what does it mean to base an exhibition of recent lens-based art on a single country, even if that country, Israel, is central to the world's current geopolitical affairs? And what does the inclusion of the journalistic term *dateline* in the exhibition's title signify? If on the face of it the title implies a news report on the state of the State of Israel, its more suggestive (and surely more interesting) meaning encompasses that branch of contemporary art that is fully engaged both with place as a subject for aesthetic exploration and with the particularities of our historical moment, which, like it or not, defines for us the very notion of what place might be.

In a world in which franchises, skyscrapers, and even fashion are marked by rampant uniformity, ideas of place have a compelling and urgent complexity. Long ago, we assume, human beings identified first and foremost with the land that they worked or the villages of their forefathers. Place names have been used as the main ingredients of human names, as with the seventeenth-century painter Claude Lorrain, born in the Lorraine, or the twentieth-century photographer Gyula Halász's better-known pseudonym, Brassaï, he who was born in Brassó. With the rise of the nation-state our ancestors learned to identify with the flag that led them into battle against others bearing flags. Of course there were always exceptions to this order, the outsiders and migrants whose residency and patriotism vis-à-vis the nation-state were called into question. Often these were Jews and Gypsies, people who served as distinguishable "Others" for the dominant culture and thus were often cast as pariahs.

But place is more than an arena of political contestation or military domination. In a world that is showing signs of rapid warming, and of the climatic and ecological changes that are sure to accompany it, place is also an environment, a repository of

1. **Dinh Q. Lê** (Vietnamese, b. 1968), *Untitled (Cambodia Series #9)*, 1998. Chromogenic print and linen tape, 59 × 41 in. (149.9 × 104.1 cm). Collection of Anne Hoger and Robert Conn, Del Mar, California

emotions based on a relationship between the natural world and the human one. Settlers in the American Midwest, the novelist Wright Morris has reminded us, called their family farm tracts "the home place." Nature writers from John Muir to Wendell Berry have spoken of place in nearly mystical terms, as if our experience of nature in its own element has healing powers. Perhaps it does.

All this has to do with place as a sense of emplacement, a site of belonging through which human beings derive their sense of identity. But emplacement also carries with it an opposite, its Other: displacement. The acute feelings of longing we experience for home, for the place where we are centered in the world, occur only when we are away from home, or deprived of it. This sense of place has become a rich source of material for contemporary artists, especially those whose lives have taken them far from their roots, or whose roots have been plowed under. Dinh Q. Lê, a Vietnamese artist trained in the United States, weaves together color photographs in a revival of his family's traditional handicraft (fig. 1). Rirkrit Tiravanija, born in Argentina to Thai parents and living in New York, uses the legacy of his grandmother to prepare meals for guests, an act that defines his inherently social art. In quite distinct ways the African American artists Fred Wilson and Kara Walker examine the erasures of slavery and racism from U.S. history and culture.

Israeli artists, as well as those artists who come to Israel out of filial obligation or simple curiosity, almost unavoidably locate their work around place. Even a simple landscape photograph that looks out over a distance may trespass beyond a border or bound-

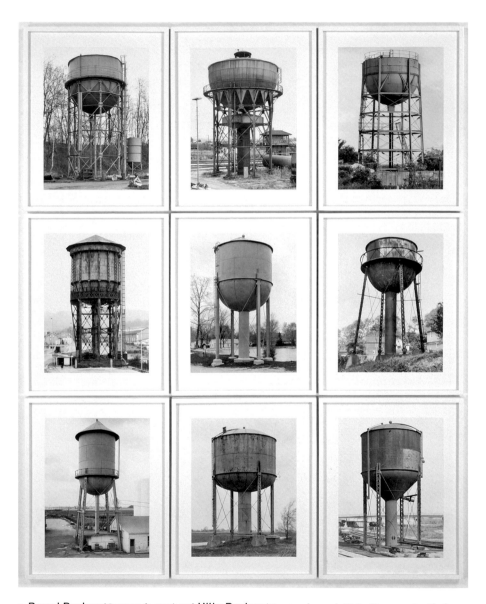

2. **Bernd Becher** (German, b. 1931) and **Hilla Becher** (German, b. 1934), *Water Towers,* 1980. Black-and-white photographs mounted on board, 61⅞ × 48⅞ in. (157.2 × 124.1 cm) overall. Solomon R. Guggenheim Museum, Purchased with funds contributed by Donald Jonas

ary, or accidentally take in a militarily restricted site. Portrait photographs and candid street pictures raise questions: Jew or Arab? Israeli or Palestinian? Ashkenazi or Sephardi? Places of origin contest with places of residence, places of worship, places of control.

"Dateline: Israel": a dateline is what starts a story in a newspaper—place, followed by date. Journalists put great store in it: being present in the place they are reporting on, and then writing the news in timely fashion. Instead of telling us what was, which is what a timeline does, a dateline says, "This is happening now." In the instance of these assembled photographs and videos, what is happening now is a matter of place. Whether directly documenting life in twenty-first-century Israel or using it as the pretext for a more personal, expressive agenda, the artists here reveal a range of contemporary attitudes about Israel as a political and cultural construction. As important, they employ the large range of options available to contemporary artists who base their art on camera images. Whether the image is a result of new digital technologies or of conventional or unconventional uses of traditional photochemical processes, or whether it exists within the moving stream of video is almost beside the point—except as an illustration that ours is a hybrid era in which Modernist distinctions that privilege one medium over another are totally passé.

It was not always thus, however. For most of its history photography struggled to be acknowledged as a part of the art of its times, even as its useful functions as an instrument of knowing and understanding the world flourished. The photograph was accepted as a medium of documentation long before it fully entered into the art world, and its status as a document continues to inform even its most aesthetic uses. (One thinks by way of example of the Düsseldorf photographers Bernd and Hilla Becher and their students, Andreas Gursky, Candida Hofer, Thomas Ruff, and Thomas Struth, all of whom enjoy a current popularity [fig. 2].) As documents, photographs supply evidence of things far off

and out of sight (and often of mind), and they serve both as historical records of how things once looked and as ideological constructs of how we want things to look and to be understood.

Empire, Nationalism, Internationalism

Photography within the land of Israel has a long and complex history, starting back when its territory was a part of a much larger construct called (in the West) the Holy Land. Remarkably, photography arrived there the same year it was introduced to the European public: 1839. This was more than one hundred years before the State of Israel came into existence, of course, so it would be more accurate to say that it arrived in Egypt, Palestine, and Syria, the favored destinations of the photographers whose albums flooded Europe over the next quarter-century. Europeans had a seemingly unquenchable thirst to see pictures of the pyramids, of the font of Christianity, and of the site of their mostly futile battles during the centuries of the Crusades.

What inspired photographers to take their infant technology so rapidly to such distant lands? One might believe it was spiritual fervor; that the prospect of having images of biblical sites that were as accurate and detailed as Nature herself inspired both European artists and their largely Christian prospective clientele. Most current accounts downplay archaeology and faith and instead emphasize imperialism. As Edward Said, Frantz Fanon, Homi K. Bhaba, Noam Chomsky, and other scholars critical of European colonialism have suggested, France, England, and other industrializing nations in the nineteenth century were competing to build colonial empires. Thus, the rise of what has come to be called Orientalism. In Said's words, "Orientalism [is] a Western style for dominating, restructuring, and having authority over the Orient."[1] Photography was both evidence of and an agent for this urge for domination and authority; in 1851 Francis Wey, an early

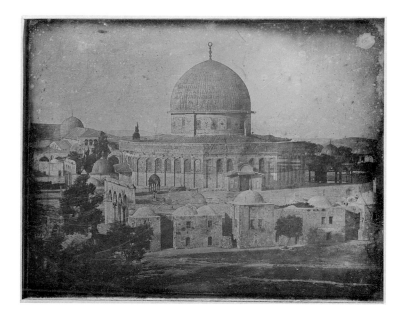

3. **Joseph-Philibert Girault de Prangey** (French, 1804–1892). *Jerusalem (Grande Mosquée, prise du palais du Pacha)*, 1844. Daguerreotype, 7⅜ × 9½ in. (18.6 × 24 cm)

commentator on photography, called pictures that document the Orient "*les conquétes pacifiques*"—peaceful conquests.[2]

The first photographs of the Holy Land were taken in Jerusalem by Horace Vernet, a French painter of some reputation, and his pupil, Frédéric Goupil-Fesquet, who arrived in 1839 bearing daguerreotype outfits.[3] They were followed by scores of others, using more advanced if no less difficult processes, over the next fifty years (fig. 3). Few were in any sense indigenous, since resident traditional Muslims and Orthodox Jews considered the camera a producer of "graven images," presumably forbidden by their respective religions. Many of these pictures, in the form of original prints, stereo views, halftone reproductions, and eventually postcards, were sold to the tourists who began flocking to the area in the last quarter of the nineteenth century.

A new subject for photographers—and a new rhetorical purpose for their images—arose in the 1880s, when the growing strength of the Zionist movement in Europe and ongoing persecution of Jews led to a surge in emigration to the Land of Israel. The new émigrés of this "first aliyah" demanded of photography a different kind of documentation, one based on possibility instead of ruins. Armed with the latest photographic technology, which included hand-held cameras, dry plates, and film, sympathetic photographers recorded the new settlements and their occupants, as well as the armed guards who protected them; most of these pictures were for the benefit of benefactors and Zionist recruiters back in Europe. The photographers generally are unknown today, but the existence of their images demonstrates how quickly cultural production can change when circumstances and ideology warrant.

Throughout most of the twentieth century this brand of optimistic, advocacy-based documentation persisted, with photographers depicting kibbutzim, new settlers, and agricultural workers as heroic figures persevering against all odds (fig. 4).[4] There were other types of photographs being taken on a daily basis, of course, including photojournalism, fashion, portraiture, and even art. (One example of an art photographer was Helmar Lerski, a Swiss Jew who emigrated to the Land of Israel in 1936 and whose idiosyncratic work was adopted as part of the vanguard New Photography movement in Europe; see fig. 5.) With the end of the British Mandate and the declaration of the State of Israel in 1948, followed by war, terrorism, and assassinations throughout the Middle East, came photojournalists like Robert Capa and David Seymour (known as Chim), combat veterans and founders of the Magnum photo agency (fig. 6). Their pictures became key instruments through which the fledgling State of Israel was depicted to the rest of the world.

The flourishing of photography with a primarily aesthetic intent is a more recent development, not only in Israel but also

throughout the world. In the United States, for example, the development of art-world structures that support creative photography—museum departments, commercial galleries, the teaching of photography in college-level art programs, criticism, art-historical research—built slowly over the 1960s and 1970s. This was also the time in which many artists, rebelling against the commercialization of painting and sculpture, turned to photography and video as means of documenting their "dematerialized" artworks—and for making new kinds of art. In Europe, photography entered the art world in similar fashion at the same time.

Several of these new-era artist/photographers took their images and ideas to Israel in the decades that followed, influenc-

5. **Helmar Lerski** (Swiss, 1871–1956), *Palestine*, 1939. Gelatin-silver print, 7¾ × 6¾ in. (19.7 × 17.1 cm). The Jewish Museum, New York, Purchase: Miriam and Milton Handler Endowment Fund, 1996–41

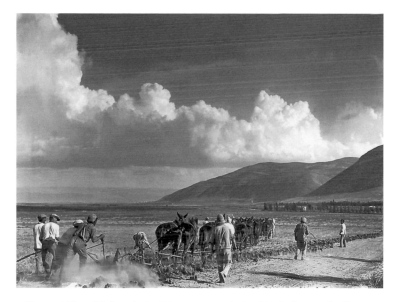

4. **Shmuel Yosef Schweig** (Galician, 1902–1984), *Ploughing in the Jezreel Valley*, 1928. Gelatin-silver print. Silver Print Gallery, Ein Hod Artists' Village, Israel

RIGHT: 6. **Robert Capa** (American, b. Hungary, 1913–1954), *Immigrants*, 1950. Gelatin-silver print, 16 × 20 in. (40.6 × 50.8 cm). The Jewish Museum, New York; Gift of Cornell Capa, 1994–588

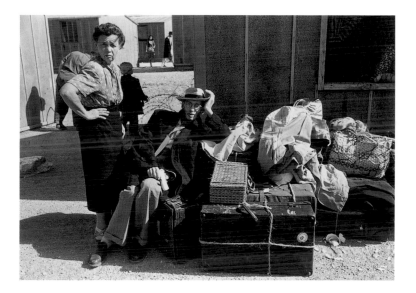

ing photographers there. In addition, Israelis such as Simcha Shirman and Boaz Tal took advantage of opportunities to study photography in the United States and Europe and then returned home with new perspectives (figs. 7, 8). Meanwhile, institutions within Israel grew to support an active photography community, notably with the establishment of photography departments and exhibition programs by the Israel Museum and the Tel Aviv Museum. Commercial galleries soon followed. In short, Israeli photography in the last quarter of the twentieth century was an international affair marked by interchange with and cross-fertilization from an increasingly cosmopolitan world of photography and art.

The atmosphere for creative photography in Israel also was advanced significantly by the founding in 1978 of the Camera Obscura School of Art in Tel Aviv and the establishment in 1986 of a degree-granting program in photography at the Bezalel Academy of Art and Design in Jerusalem. A young Israeli couple, Arie Ham-

8. **Boaz Tal** (Israeli, b. 1952), *Three Generations at My Parents' House,* from the series *My Father: From Warsaw to Jaffa, 1935–1992,* 1992. Gelatin-silver print, 49⅝ × 48¾ in. (126 × 125.8 cm). The Jewish Museum, New York, Purchase: Ariana and Jack Weintraub Foundation for the Arts Fund, 1992–1993

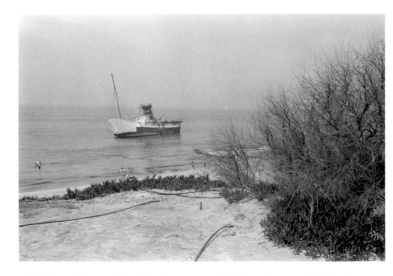

7. **Simcha Shirman** (Israeli, b. Germany 1947), *Horizon Line,* 2000. Gelatin-silver print, 14½ × 21⅞ in. (37 × 55.5 cm). Gordon Gallery, Tel Aviv

mer and Michal Rovner, established Camera Obscura as a private, independent school for the study of photography and film. By providing an atmosphere of seriousness where aesthetic debates could flourish, and by bringing in practitioners and critics from abroad, Hammer and Rovner contributed to the development of a new wave of Israeli photography.[5] The photography program at Bezalel added to the visibility of photography practiced as an art, not as reportage.

9. **Michal Rovner** (Israeli, b. 1957), *Outside #11*, 1990–91. Chromogenic print, 19⅞ × 19⅝ in. (50.5 × 49.8 cm). The Metropolitan Museum of Art, New York; Purchase, the Horace W. Goldsmith Foundation Gift, 1992 (1992.5040)

Fueled by photography's new visibility, young Israelis increasingly fanned out across Europe and the United States not only to study but also to live as expatriate artists abroad—among them Rovner, who moved to New York and whose work in photography and video is now shown internationally (fig. 9). These artists— many of them participants in what Irit Rogoff has called "the diaspora's diaspora"—have served as conduits of the latest practices and critical approaches to an Israeli art community more interested in international than national audiences (fig. 10).[6] Several of

the artists in this exhibition are internationalist in this sense: Yael Bartana is an Israeli living in Amsterdam; Ori Gersht studied at the Royal College of Art in London, where he now lives; Leora Laor lived in the United States for several years and is now a resident of Tel

10. **Guy Ben-Ner** (Israeli, b. 1969), *Treehouse Kit*, 2005. Sculpture and video installation (originally commissioned for the Israeli Pavilion at the Fifty-First Venice Biennale), wood and hardware sculpture, carpet, mattress with silk-screened cover, DVD (running time: 10 minutes), dimensions variable, tree: 15 × 15 × 13½ ft. (4.6 × 4.6 × 4.1 m). Postmasters Gallery, New York

Aviv; and Orit Raff studied at Bezalel Academy and the School of Visual Arts in New York, where she lived until recently moving to Tel Aviv.

Not surprisingly, the historical traditions of photography within the Land of Israel that I sketched earlier have little to no importance for this generation of internationalist photo-based artists. They aim to reach audiences not as advocates for a particular cause or ideology but as critical questioners of their given realities. In this sense they share the broader tenor of today's art, which is to unsettle our conventional ways of seeing the world in hopes that we will come to understand it differently. This is not quite "deconstruction," as literary theorist Jacques Derrida meant the term, but it does share the conviction that meaning is constructed, not fixed, and that images are not truths, but representations.

Most of the artists in the exhibition live and work in Israel, which makes sense given that the country is the show's subject. This might also explain why the work of Palestinian artists is almost entirely absent, and one might guess that disputes about national boundaries were a factor in the decision of some artists of Palestinian origin to turn down an invitation to participate. A Palestinian who is included, Noel Jabbour, is represented by a work that directly addresses the issue of territoriality. Her composite photograph, *Abu Dis Wall,* shows Israel's controversial West Bank barrier from both sides, suggesting that it is not only Palestinians who are subjects of, and subject to, the division of people and land (pl. 14).

Indeed, given the extent to which photographs of Israel have been deployed in the service of ideology and propaganda—in an effort, in the first place, to construct a holistic image of an Israeli people distinct from their Arab and Palestinian neighbors, and, secondly, to control the portrayal of their conflicts—positing the existence of a cosmopolitan art photography oblivious to the dynamics of the Middle East conflict would seem seriously naïve.

This may explain why the artists of *Dateline Israel,* no matter where they call home, see fit to utilize or address the rhetoric and assumptions of what historically has been called documentary photography.

Updating the Document

On the face of it, much of the work here might be called reportage, especially that of the photographers whose work is frequently published in magazines and newspapers. Pavel Wolberg, a Russian-born Israeli and graduate of the Camera Obscura school, was working as a photojournalist when he took the series of pictures shown here, depicting the face-off between settlers in the Gaza Strip and the soldiers sent to evict them (fig. 11). Gillian Laub, a photojournalist born and based in New York who frequently works in Israel, has for the last several years made portraits of Arab Israelis, and of victims of violence on both sides of the Israeli-

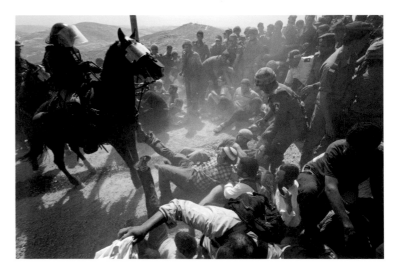

11. **Pavel Wolberg** (Israeli, b. Soviet Union 1966), *Israeli Police Confronts the Jewish Demonstrating Settlers During the Evacuation of Mitzpeh Yitzhar, 2004,* 2005. Digital chromogenic print, 19¾ × 27½ in. (50 × 70 cm). Dvir Gallery, Tel Aviv

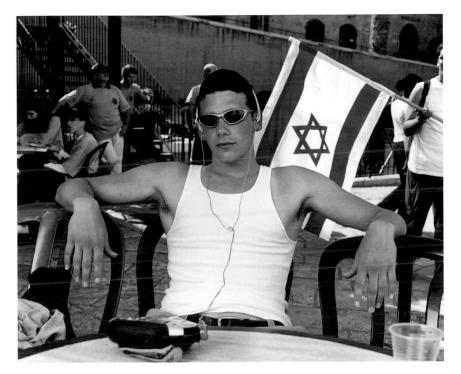

12. **Gillian Laub** (American, b. 1975), *Yussie in the Old City, Jerusalem, Israel*, 2002. Chromogenic print, 30 × 40 in. (76.2 × 101.6 cm). Courtesy of the artist and Bonni Benrubi Gallery, New York. "My whole family is back in America. I was just there and everyone, my friends and family, were trying to convince me to stay. They were afraid for me to go back to Israel because of the situation. I understand why they worry, but I tried to explain that my heart and soul is in Israel and I cannot live in America with this part missing. This is why I am back in Israel, trying to get into a school. As I see it, a person has two ways of living . . . either through their brain and thoughts, or their heart and soul. I am happy with my decision. I have to and will always follow my heart."

13. **Gillian Laub** (American, b. 1975), *Mahmoud, Jaffa, Israel*, 2002. Chromogenic print, 20 × 24 in. (50.8 × 61 cm) Courtesy of the artist and Bonni Benrubi Gallery, New York. "I am eighteen years old and studying accounting at Dov Hos school. During the school holidays I work in construction. In the past two years, many things have changed for my family. With the situation today in Israel, I don't go out socially to parties at all like I used to. I am not in contact with my Jewish/Israeli friends like I once was. I wish the State of Israel would get over it and give up this small piece of land so we can finally live in peace. I am proud to be an Israeli citizen, even being an Arab, but the country needs to grow up and make some sacrifices. Nobody wants to live this way anymore."

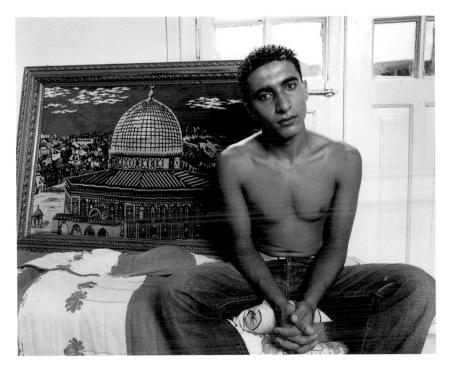

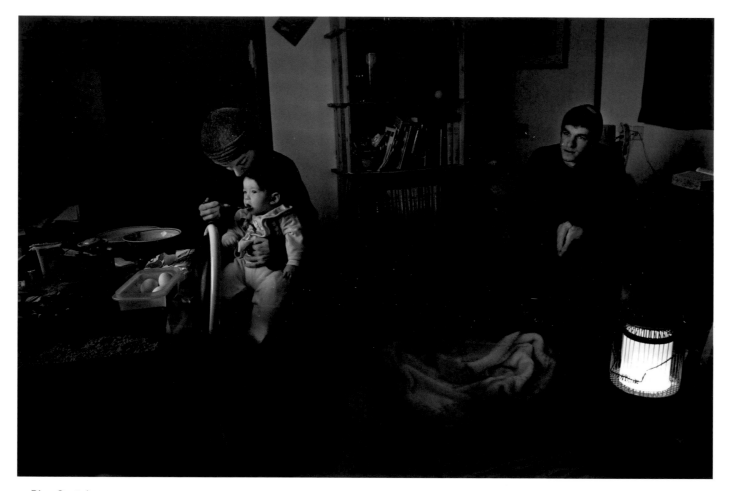

14. **Rina Castelnuovo** (Israeli, b. 1956), *Hilltop Youth, West Bank, Winter* 2004 (from the *Settlers* series), 2005. Chromogenic print, 30 × 40 in. (76.2 × 102.6 cm). Andrea Meislin Gallery, New York

Palestinian conflict (figs. 12, 13). News photographer Rina Castelnuovo's observations of religious life are among the most gentle of the images in this vein, using color to set a mood of reflective calm (fig. 14, pl. 18). These photographers obey the first rule of photojournalism: allow subjects to be the agents of their feelings.

Other work takes on the characteristics of landscape photography. Sharon Ya'ari photographs odd conjunctions: cypress trees on the edge of an excavation, a fertile zone in the middle of a highway (fig. 15). Igael Shemtov, who teaches in Bezalel's photography program, shows the land as a bleached, sun-baked conjunction of

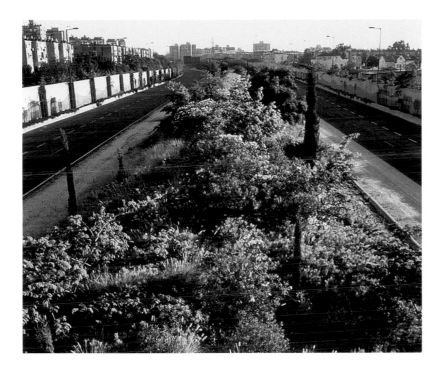

15. **Sharon Ya'ari** (Israeli, b. 1966), *Freeway*, 2002. Chromogenic print, 48¾ × 56¾ in. (124 × 144 cm). Private collection, Old Westbury, New York, Arranged by Lombard-Freid Fine Arts, New York

16. **Igael Shemtov** (Israeli, b. 1952), *Untitled*, 2000. Chromogenic print, 58½ × 49½ in. (150 × 127 cm). Loushy Art & Editions, Tel Aviv

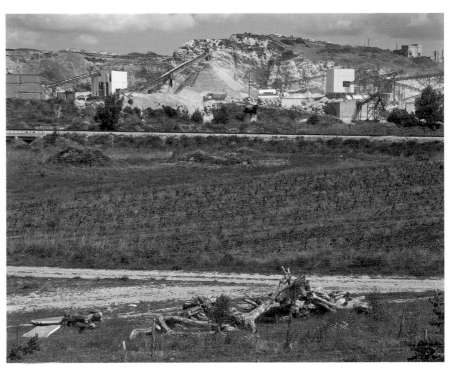

nature and industrial deformation (fig. 16, pl.6). Guy Raz looks away from the land and its famous cities to stare out to sea, identifying a border that is policed by guard towers of a benign sort. Raz's, Shemtov's, and Ya'ari's work is more skeptical and restrained than the distanced views of Tel Aviv and Jerusalem, respectively, by Wolfgang Tillmans and Wim Wenders, although Wenders does show us a dump in the foreground of the Mount of Olives (pl. 2). These international (if not transnational) artists seem to operate above the ground, scanning the landscape as disembodied observers.

Rineke Dijkstra, a Dutch artist who works in the observational style of Düsseldorf-trained photographers

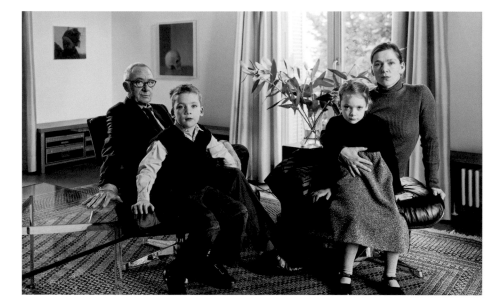

17. **Thomas Struth** (German, b. 1954), *The Richter Family I, Cologne,* 2002. Edition two of ten, Cibachrome print, laminated to Plexiglas, 52½ × 75½ in. (133.4 × 191.8 cm). Solomon R. Guggenheim Museum, Purchased with funds contributed by the Harriet Ames Charitable Trust and by the International Director's Council and Executive Committee Members

Questions of Evidence

For many others, however, the documentary status of photography is precisely the question. Leora Laor, Ori Gersht, Orit Raff, and Barry Frydlender make pictures that call the medium's objectivist, evidentiary qualities into question and, in the process, make us as viewers aware of our own subjectivity in responding to images produced by the lens. Laor—with Wolberg and Shemtov a recent winner of the Tel Aviv Museum's Constantiner Photography Award—starts with the premise of street photography and refashions it into something more lyrical and romantic. Concentrating on children, she uses light and a variety of processing techniques to create an atmosphere seemingly more akin to a cinematic version of a Polish shtetl than to contemporary life in Israel (pl. 24). Gersht's *Ghost* series depicts olive trees in old groves of the Galilee, but the photos are processed in a way that makes the trees almost vanish before our eyes (pl. 5). Raff's pictures are ostensibly centered on bread-making, but because of the mysterious manner of presentation and the selection of subject matter (an oven, for example), they suggest the horrors of Jewish history (pl. 17).

Frydlender's pictures are even less reliable as evidence, since they are in reality assemblages of images taken at different times and then combined with the help of a computer to give the illusion of a single exposure. Frydlender focuses on gathering places with a sociologist's zeal, showing us groups of young urbanites, Old World Jews, and middle-aged Arab men in enormous color panoramas (fig. 20). Some of the places he photographs are significant in terms of recent history, such as a café where a suicide bomber had struck, but as viewers we are more likely to be atten-

like Thomas Struth (fig. 17) and Andreas Gursky but with a focus on the awkward years of puberty and adolescence, has her subjects (schoolgirls, young soldiers) embody what it means to be a teenager in Israel today. In portraits that are at once unflinching and poignant, taken at annual intervals, Dijkstra marks the passage of youth into the first stages of adulthood, with all the tentativeness, incomprehension, and anticipation that this entails (pls. 22, 23). Work like hers is so convincing that questions about the status of photographs as documents, as evidence of real life, seem beside the point. Instead, she focuses our attention on how the camera constructs identity, and on how we construct an identity for the camera (figs. 18, 19).

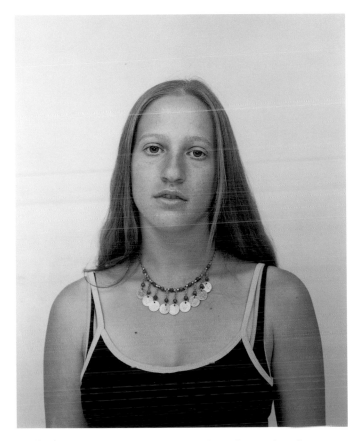

18. **Rineke Dijkstra** (Dutch, b. 1959), *Abigail, Herzliya, Israel, April 10, 1999*, 1999. Chromogenic print, 49⅞ × 42⅛ in. (126 × 107 cm). The Jewish Museum, New York, Purchase: Melva Bucksbaum Contemporary Art Fund and the Photography Acquisitions Committee Fund, 2004–60.1

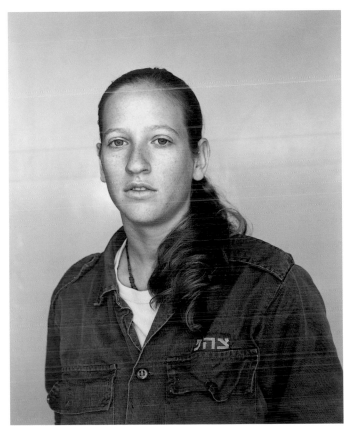

19. **Rineke Dijkstra** (Dutch, b. 1959), *Abigail, Palmahim Israeli Air Force Base, December 18, 2000*, 2000. Chromogenic print, 49⅞ × 42⅛ in. (126 × 107 cm). The Jewish Museum, New York, Purchase: Melva Bucksbaum Contemporary Art Fund and the Photography Acquisitions Committee Fund, 2004–60.2

tive to the people who inhabit them. That some of these people never crossed paths with those standing next to them only adds to the fascination the images exert.

Several of the video works exhibit an equal interest in extending the documentary tradition. Yael Bartana's *Trembling Time* uses slow motion and a fixed camera position to depict the stoppage of traffic in Tel Aviv during the moment of silence on Israel's Day of Remembrance (pl. 12). The slowing of the traffic on

a busy highway is magnified by the slowing of the frame rate, so that cars begin to seem ghostlike and time really does stand still—until traffic restarts and resumes its normal pace. In a different sense Amit Goren's *Map*, an installation of six video loops, violates documentary traditions not only by its manner of presentation but also by using a collage of scenes and sounds from a variety of locations (including Mongolia) to express essential concepts like "refuge," "home," "diaspora," and "state" (pl. 9).

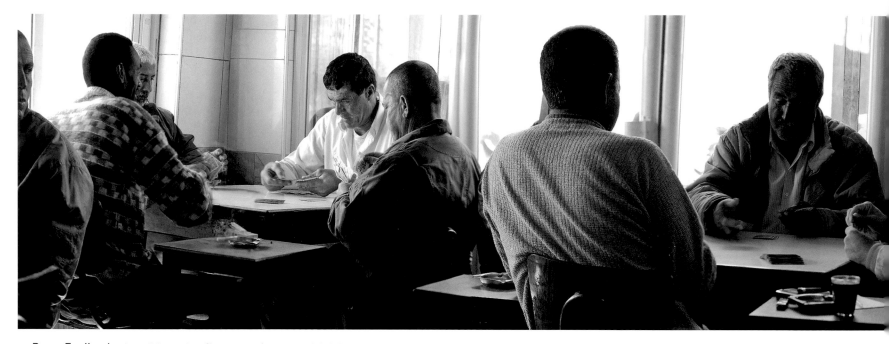

20. **Barry Frydlender** (Israeli, b. 1954), *Café, East Jerusalem*, 2004. Digital chromogenic print, 26.8 × 108.8 in. (69 × 277 cm). Andrea Meislin Gallery, New York

Catherine Yass, a British artist who was short-listed for the Tate's Turner Prize in 2002, recently made a remarkable video (*Wall*, 2004) that combines her interest in decentering visual expectations with an implicit political commentary (pl. 13). Viewing the West Bank barrier in a slow-moving pan that lasts more than thirty minutes, Yass and her camera take in both the visual power of the structure, which is an aggregate of plinthlike sections that have almost human proportions, and its disruptive social effects. Graffiti written in Arabic appears on the concrete barrier, as do blue-painted rectangles that presumably cover over other anti-wall messages. Yass's virtually pitiless scan of the wall reinforces its implacability and its crude assertion of power.

Re-Presenting Representations

The notion of questioning or challenging documentary convention is only part of what is at stake in this exhibition, however. Much of the work on view also inserts itself into a more theoretical, more political, and more arguable critique of representation itself. Several of the artists use photographs and video against themselves, as instruments capable of critiquing their own status as media. Motti Mizrachi's *Blinking*, a digital assemblage of journalistic imagery, essentially is about our inability to keep visual data and historical data discrete in the face of an overloaded information environment (pl. 10).

Michal Heiman's *Blood Test* series is even more pointed and discomfiting (pl. 11). Culled from gory but apparently newsworthy press images, the heavily processed pictures show human body parts freed of any individual identity. In a place and at a time when racial and ethnic identity is viewed as essential information in determining one's anxiety or comfort level, these pictures present an undifferentiated view of life—or, more accurately, of death. The anonymity of this evidence of violence is at heart a refusal to consider difference as the defining element of our humanity; it suggests, as does the work of Yass, Laub, and others, that we are all (at least potentially) occupiers and occupied, terrorizers and terrorized.

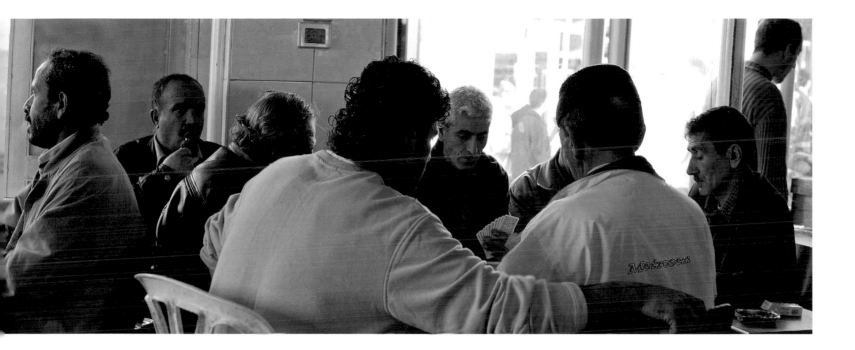

The "tests" in Heiman's work refer to projective tests used by psychologists, the most famous of which are the Rorschach ink blots, bilaterally symmetrical stains in which patients are urged to perceive and identify recognizable figures. In a sense, all representations are essentially abstract until we interpret them, and our interpretations are not fact-based but projections of our own experiences. This is to say that what we see is determined by who we are as well as by where and when we see it. The idea is central to Boaz Arad and Miki Kratsman's collaborative, untitled video piece in which we see one man's face after another in a seemingly endless procession (pl. 16). There is an abstract beauty to the work that is reinforced by the inevitability of each individual's replacement, but this meaning is reordered if we know, or are told, that the men are Palestinian laborers passing through an Israeli checkpoint.

If we can say that the major story being written in Israel today is about who belongs to what land, it can also be said that the lens-based images brought to us by photography and video also occupy disputed terrain. In purporting to show evidence of what that land and its peoples look like today, these images suggest that reportage is not a matter of fact but of function, that objectivity is a convenient illusion or at best a style, that each of us configures meaning from our own experience as much as from the representations that surround and define that experience. Photography and video are the mediums of *Dateline Israel* because they cross whatever wall or membrane we set up to divide art from social reality—just as Jabbour and Yass cross the physical barrier of the wall at Abu Dis. The line between journalism and self-expression is like the green Armistice line that half a century ago divided Jerusalem between Arab and Jew, a line that the Mexico City–based Belgian artist Francis Alÿs recently made tangible in a walk he took with a dripping paint can in the video *The Green Line*. This work, unavailable for the exhibition, is also known by another title, a title that could serve as the epigram for all the art and artists represented here: "Sometimes doing something poetic can become political and sometimes doing something political can become poetic."

Concerning Life in Israel

Nissan N. Perez

L ife in Israel is marked by a great number of forces, some historical, others the results of the current national, social, economic, and geopolitical situation. From the indelible memory of the Holocaust to the daily concerns of the country now, the reality of contemporary Israel is that living—even surviving—is an incessant challenge. In such an environment, creating art can seem, at times, a gratuitous and futile act.

How then do Israeli artists come to terms with a distressing reality that encompasses violence, insecurity, social discrimination, political instability, and other social ills? Their work proposes a wide range of possibilities for the viewer, from first-hand involvement in the life of their country to a total and conscious escapism. It is work that is laden with tensions, hopes and prayers, grief and joy, trust and suspicion. Israeli art, then, should be examined in relation to current conditions—the contested borders and the battle for territory, the threats of war and terrorism—which are bound inextricably to lens-based arts in Israel now.

The salient feature of contemporary Israeli art, especially photography and video, is its social consciousness. Artists today try to raise awareness of every aspect of Israeli life and wish to incite the viewer to reconsider opinions and to take positive social action. As utopian as this might sound, artists see that a bit of optimism is necessary to realize their goals. They create their work by pointing out wrongs and injustices even as they suggest the chance for a better future. In a place where the past and the present, as well as the personal and the political, are inseparable, Israeli artists excel at transforming the art of living into living art.

Because of their physical and cultural distance from other art centers, contemporary Israeli photography and video remain peripheral to some extent, often operating on the margins of the art world. Although they are featured in high-profile venues like the Venice Biennale and Documenta, Israeli lens-based artists have struggled to become part of the mainstream of international

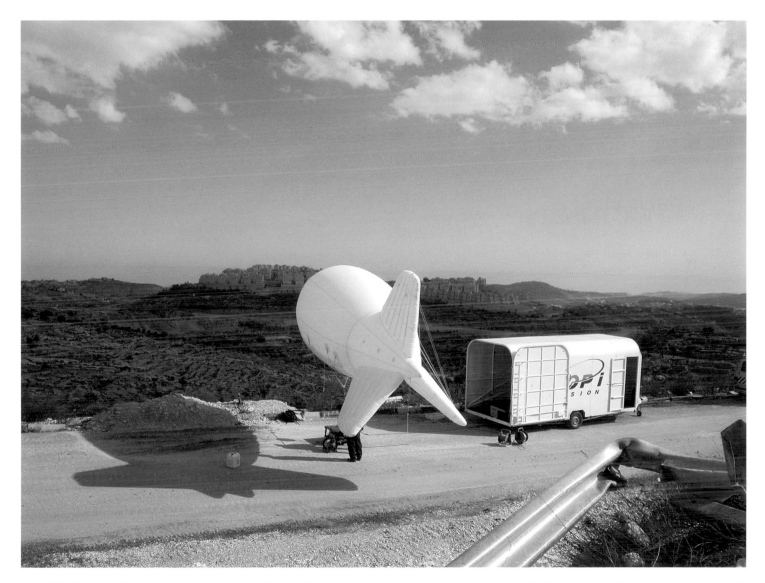

1. **Yael Bartana** (Israeli, b. 1970), *Freedom Border*, 2003. Video installation, 3 min. Annet Gelink Gallery, Amsterdam. In this image from the video *Freedom Border*, a surveillance blimp with small cameras installed on the underside is about to be launched. Its purpose is to monitor a section of the Israeli-Palestinian border.

art. In doing so, they often create a fascinating synthesis, joining cosmopolitan values to their own cultural, social, and political contexts. Israelis are torn between national myth and collective memory. As Israeli society matures, religious and national values are being reconsidered and placed in a contemporary perspective that involves the breaking of many traditional taboos. This in itself implies a rupture with the past that is often painful and leads to a crisis of identity. Moreover, as a nation, Israel is burdened by the weight of memory: the Diaspora, the Holocaust, the many wars the country has endured, and the staggering number of casualties Israel has mourned. None of these occurrences is distant enough for objective consideration; still, these heavy historical burdens are not always easily discernible in art made by Israelis. While some artists tackle these subjects directly, others embed them in their work—and still others ignore them, preferring to take refuge in the personal and the imaginative.

For contemporary Israeli artists, issues of human rights, racism, and humanism are extremely concrete subjects. Israeli artists face a harsh reality, with a faltering peace process, mandatory military service, constant friction with the Palestinian Authority, and issues of security and terrorism always in the foreground. These concerns preoccupy all Israelis, and artists often seize upon them for their work, with each artist expressing his or her vision in a different way. The range of artistic approaches reflects, in part, the fact that Israel always has been an immigrant society in which numerous cultural and intellectual streams have converged during the past century.

This convergence did not favor the formation of a well-defined aesthetic tradition in the country until the 1970s, when native-born Israelis began changing the artistic climate. Although still absorbing relatively large numbers of immigrants, today's Israel has ceased being a country of immigration to the degree it was. It is still a melting pot, but it has now developed a strong and

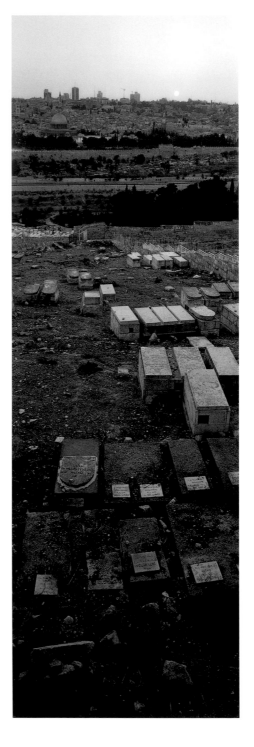

2. **Wim Wenders** (German, b. 1945), *Jerusalem Seen from Mount Zion,* 2000, Chromogenic print, 114⅛ x 45⅞ in. (289.9 × 116.5 cm). The Jewish Museum, New York, Purchase: Photography Acquisitions Committee Fund and Alice and Nahum Lainer Gift, 2004–61

relatively well-established local culture and an artistic tradition that is robust enough to absorb and counterbalance influences introduced by immigration. Nevertheless, after a hundred years of tumultuous existence and fifty years of independence as a state, this multifaceted society is still in conflict with itself, its identity, and its self-image, and this condition leaves a deep imprint on Israeli art.

Israel is a country that devotes a tremendous amount of time, thought, and energy to the question of national identity, especially through symposia and philosophical discussions. What, in fact, is Israeli national identity? There is no clear-cut answer. Although more than half a century has passed, Israel still defines itself through a process of elimination—that is, by specifying what Israeli identity is not.

Every language is a unique means of experiencing and expressing life and the world around us, and most often they are culturally specific. Today's Hebrew mirrors clearly the search for identity by the younger generation, a new identity that has broken with the ethos of the heroic past of the pioneers and is torn between two worlds. Israelis have invented a number of colloquial Hebrew expressions—such as *korach hametziut* (necessity of reality) and *ein brerea* (no alternative), and slogans such as *am bematsor* (a nation under siege) and *am besakanat hakhada* (a nation in danger of extermination)—that express the state of urgency prevailing in the country. On the one hand, the younger generation of native-born Israelis feels a tie to the Middle East, and on the other it has a desire to belong to the West. A perfect example of this is one of the most popular expressions used by the younger generation: *yalla bye,* a combination of Arabic ("let's go, hurry up") and English ("see you later") that elides Hebrew and is symptomatic of the attitude of the new generation. The title of the recent Israeli rock hit "We Are a Screwed Generation" is another indication of many young people's state of mind.

The questioning of national values comes as a reminder and as a reproach to the average citizen's stereotyped views. This accounts for one of the distinctive traits of artistic creation in Israel: artists, critics, and most of the cultural establishment consider it their prime duty to be militant and politically incorrect. In a country where emergency regulations are enforced and are extended regularly without question, and where military censorship is consistently applied, to oppose government policies appears as an act of heroism.

It seems fitting, then, that so many artists who question authority have chosen to take pictures or make videos. After all, lens-based arts had been considered to some extent the enfant terrible of the arts in Israel, although photography and video now are generally embraced by artists and critics alike. As ideas about art evolve, so does the camera image. The multitude of techniques and creative strategies used by artists, reinforced by new discourses and theories borrowed from other media and fields, has continuously informed the goals that animate their works: to provide a lucid and incisive look at a land and a way of life, to capture a changing and scarred landscape, and to confront viewers with a caustic critique of widely held values in Israeli society. Theirs is a constant reevaluation of Israel's collective knowledge and comprehension of itself and its culture, and a most courageous attempt to foster a better understanding that, by raising the nation's consciousness, harbors the hope for a viable future.

A Matter of Place

Susan Tumarkin Goodman

A particularly resonant expression of the contradictions in Israeli society is the New Year's greeting created in 2006 by artist David Tartakover, one of Israel's most outspoken peace activists and winner of the 2002 Israel Prize (fig. 1). He has used photography as the basis of his politically motivated posters to draw attention to the visible forces that shape life in his country. Usually his eagerly awaited annual greeting is edgy and barbed. The artwork for 2006 especially seems to have struck a chord. By juxtaposing hacked-up olive trees with a quotation from Deuteronomy proclaiming the richness of the land, we are asked to confront the dystopian situation in Israel.[1] Tartakover's photography and message set the tone for the present exhibition of lens-based art created in Israel since the Al-Aqsa Intifada erupted in September 2000.[2]

In the almost sixty years that have passed since the founding of the State of Israel, people outside the country, whose knowledge is informed mainly by media accounts, know it primarily as a place of conflict. As one Israeli critic wrote, "The last decade has been in many ways a decade of the two intertwined social powers that feed off each other: Terrorism and Television."[3] In fact, the all-consuming character of political reality influences every aspect of creative culture in Israel, providing the subject for numerous books, films, plays, and artworks. For observers outside Israel, it is important to remember that religious and national values are constantly reconsidered there, and the current, more complicated view of the country that has evolved has replaced the utopian model of an earlier era.

Israel Through a Foreign Lens

As Israel has commanded the attention of the international community, an increasing number of artists from outside the country have traveled there to capture its essential character.[4] Interna-

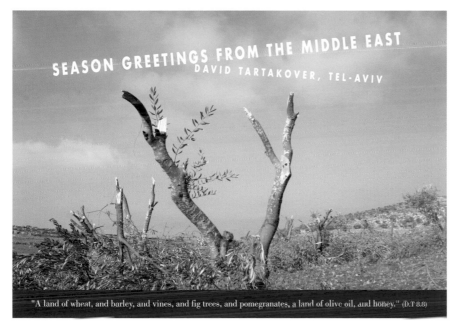

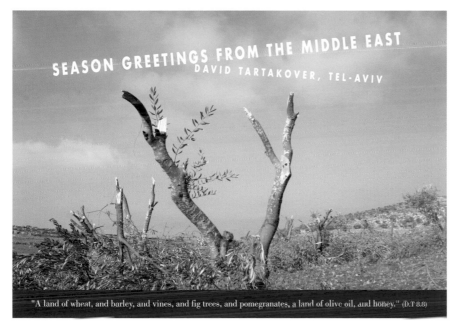
SEASON GREETINGS FROM THE MIDDLE EAST
DAVID TARTAKOVER, TEL-AVIV

"A land of wheat, and barley, and vines, and fig trees, and pomegranates, a land of olive oil, and honey." (D.T 8.8)

1. **David Tartakover** (Israel, b. 1944), *Season Greetings*, 2006. Postcard, 8¼ × 11¹¹⁄₁₆ in. (21 × 29.7 cm). Collection of the artist

tional artists join Israeli artists in engaging the imagery of both conflicting and compatible ideologies prevalent in the Jewish State. While they employ different methods to depict and interpret the prevailing climate, all the artists have a personal connection with Israel: either they were born there or they have had a profound experience in the country itself. The alternative vision of the non-Israeli is explored in the media pieces of such artists as Nedko Solakov and Francis Alÿs as well as the collective called Multiplicity, all of whom dissect the status quo with remarkable immediacy. For these artists and others from outside Israel, including Rineke Dijkstra, Gillian Laub, Wolfgang Tillmans, and Catherine Yass, the country struck a chord that resonated with themes in their other work.

Often artists engage in acts of blatant provocation. In the video *Solid Sea 03. The Road Map,* the Italian-based group Multiplicity does not flinch from calling our attention to what we do not wish to see. Ostensibly, Multiplicity explores the differences between similar trips made by a Palestinian and an Israeli without expressing any overt judgment.[5] Although the two journeys are geographically similar, the travel times vary widely: whereas the Palestinian traveler takes over five hours to arrive at his destination, the Israeli traveler takes just over one hour to complete the same route. By merely making a real-time record, Multiplicity implicates the viewer by inviting an interpretation of the charged situation. The Belgian artist Francis Alÿs, in one of his multimedia works, walks along the political Green Line that runs through the municipality of Jerusalem, all the while making a green line with a leaking can of green paint.[6] Employing his usual artistic vehicle—a walk—he makes an actual line that mimics the historic 1949 Armistice line separating Israel and the occupied territories.[7] In this way, the artist is alerting us not only to the delicate issues of borders and ceasefire lines, but also to the power of art to effect political change.

In the Bulgarian artist Nedko Solakov's two-channel video and wall drawing *Negotiations,* the artist reflects the anxiety often felt by foreigners who visit Israel (fig. 2). After Solakov was offered a one-person exhibition in Tel Aviv, his fears were awakened by ongoing terror incidents. In *Negotiations,* the artist explored the attitudes of Palestinians and Israelis, asking official representatives of both Israel and the Palestinian Authority in Bulgaria to arrange for a two-day ceasefire so he could feel safe while in Israel. Solakov's interviews with the government officials are played simultaneously on two video monitors. The understandable fixation in Israel on security-related issues is a compelling

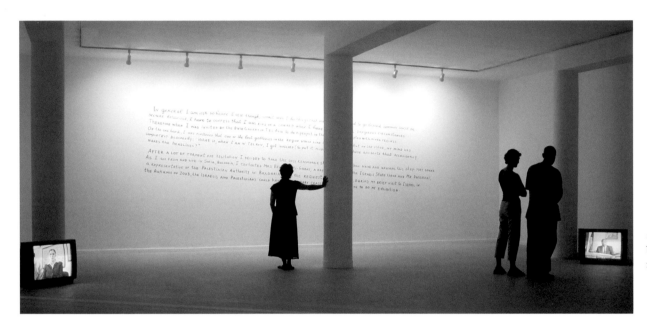

2. **Nedko Solakov** (Bulgarian, b. 1957), *Negotiations*, 2003. Video installation. Dvir Gallery, Tel Aviv

theme for any non-Israeli—images of or experiences with soldiers, checkpoints, and bag inspections are omnipresent. For Israeli artists, this is part of their day-to-day existence, but for others it contrasts with the frequently less overtly intrusive manner of government officials in Europe and America.[8]

Landscape and Urbanscape

In Israel, it is often difficult to draw the line between an environmental issue and one that is sociopolitical. When land enters the picture, it acquires meaning through its context; in a similar fashion, the appearance of objects and people may be transformed by the landscape in which they are placed. The urbanscape of Tel Aviv lent itself to the artistic intervention of German photographer Wolfgang Tillmans, who created a large-scale aerial view of the city (pl. 1). The artist manipulated the print to create an eerie yel-

low cast. While the light transforms the view, binding the city together and implying a shared experience, the dramatic optical effects distance the viewer from the scene at hand. The golden lighting causes *Aufsicht (yellow)* to resemble older photographs, implying the multiple layers of history embedded in the region. German filmmaker Wim Wenders's vertical photographic panoramas of Mount Zion and the Mount of Olives communicate the sense that in Jerusalem events of the past as well as of the present are embedded in a site (see Perez essay, fig. 2, and pl. 2). Wenders implies that natural forces and time have eroded and erased historical memory, and the once spiritual, mystical sensibility of these sacred sites seems to have vanished. *Jerusalem Seen from the Mount of Olives* invokes the traditional belief that Jews who have been buried on the Mount of Olives will be the first to rise from the dead with the coming of the Messiah.[9] But the incongruity here suggests that, were it to happen, the resurrected Jews would face

a hill strewn with garbage and, on the horizon, the Al-Aqsa Mosque on the Temple Mount. In *Jerusalem Seen from Mount Zion*, a similar juxtaposition exists—the Tomb of King David, which is unseen in the photograph, overlooks the Al-Aqsa Mosque, showing the close proximity of two distinct traditions.

By applying images of Jerusalem to a pair of folding screens, British artist Mark Wallinger has transformed a real object into a richly suggestive sculpture (pl. 4). Wallinger created *Painting the Divide (Jerusalem)* when he was invited to participate in an exhibition at the Sultan's Pool in the Israeli city. The screen provided an effective means to abut images of the Sultan's Pool (left side) and Mishkenot Sha'ananim (right side), two locations in Jerusalem that the artist believes speak eloquently to the history of the region. The Sultan's Pool, believed to be built on the site of a pool from the Second Temple Period, was restored by the Ottoman sultan Suleiman the Magnificent in the sixteenth century to store water that flowed from a nearby valley. Mishkenot Sha'ananim was built in 1860 by Sir Moses Montefiore, a highly honored British Jew who constructed the first neighborhood for Jews outside the walls of the Old City.

As an artist from England whose father was stationed in Jerusalem during World War II, Wallinger was particularly struck by the British influence on Mishkenot. One of several works on screens that Wallinger has made about divided territories (others are Berlin and Famagusta in Cyprus), *Painting the Divide (Jerusalem)* represents the

numerous cultural influences at play in Jerusalem, a place that has been contested throughout history—from the Herodian period through the Turkish presence and into the twenty-first century. The zigzag of the screen alludes to the religious and political lines that have been drawn through the city, and the juxtaposition of the Sultan's Pool and Mishkenot Sha'ananim evokes the layering of cultures that characterizes Jerusalem.

Some artists depict landscape in picture-postcard-like images, but others view it as a threatened or contested space. In the photography of Ori Gersht, the gritty, heavily textured landscape in the Judean desert reveals a forbidding expanse that bears the scars of human activity or tracks of vehicles (fig. 3). Of such images Gersht has written, "There is a lot of mess and historical claims to this land." In biblical times the Judean desert was primarily a place of refuge and meditation, but now it divides Israel and the West Bank.[10] In his series entitled *Ghost*, Gersht has photographed ancient olive trees in the Galilee (pl. 5), simultaneously exploring their symbolic power and vulnerability. Each tree is an iconic image intended both as a portrait and an account of the passing of time. As one of the seven species of native plant life in

3. **Ori Gersht** (Israeli, b. 1967), *Black Mountain*, 2000. Chromogenic print, 39⅜ × 98⅜ in. (100 × 250 cm). CRG Gallery, New York

4. **Sharon Ya'ari** (Israeli, b. 1966), *Page 4,* 1999. Chromogenic print, 48⅞ × 61½ in. (124.1 × 156.2 cm). Lisson Gallery, London

Israel, the olive tree was viewed by both the Israelites and their neighbors as sacred: "The Lord named you verdant olive tree, fair with choice fruit" (Jeremiah 11:16). The artist allowed the harsh midday sun to bleach the film and fade the images of the sturdy trees, resulting in forms that appear both ghostly and delicate. In this way Gersht transforms these ancient and weathered symbols of strength into images of fragile beauty.

Sharon Ya'ari, who creates staged compositions, is another artist who uses nature as his studio. While his work is closely linked to the physical and political landscape of Tel Aviv and its environs, the unremarkable locations in his photographs are not identified and are often touched by an element of artifice. In *Cypresses,* the natural scene of cypress trees in a battered landscape is invested with an enigmatic aura, conveying a sense of indeterminate space (pl. 3). The image of cypress trees evokes the religious traditions of the region, for these were the trees that, according to the Bible, were used to build Noah's ark as well as the First Temple. And yet the four trees standing in proud isolation reveal an exposed pipe; this stark location suggests that Israel's environment is threatened by human intervention. In another resonant image, elderly people trudge up a path to their housing complex along a rough-hewn dirt walkway that ends abruptly in the middle of a grassy incline (fig. 4). Landscape also figures importantly in the work of Igael Shemtov, who has said that he is drawn to the defects and imperfections in the terrain and that he aims to create a visual conflict in his photographs between the untamed land and its development.[11] In *Landscape with Castor Oil Plant #10,* for example, Shemtov contrasts the vivid plant life with the detritus of a quarry, a dystopian view of nature that casts a harsh light on political and commercial interests in Israel (pl. 6).

In the work of Guy Raz we detect a shift away from the explicit preoccupation with nature and territorial issues to an examination of structures created to meet a communal need. The lifeguard towers in Gaza and Tel Aviv in Raz's four photographs, *Lifeguard Towers—Serial 1* share the same Mediterranean coastline, and the artist has composed the images so that the four scenes

5. **Gilad Ophir** (Israeli, b. 1957), *Shopping Center, Kibbutz Gan-Shmuel*, 2003. Chromogenic print, 47¼ × 59⅛ in. (120 × 150 cm). Collection of the artist

are linked by a common horizon line (pl. 7) . This region has a rich and layered history that informs his photographs, prompting thoughts about particular political and historical realities. These structures suggest an ominous series of watchtowers, subverting the benign qualities of the blue skies and picturesque beaches. This sense is reinforced by the flags, which show the colors of Israel and the Palestinian Authority rather than those indicating safe or unsafe swimming conditions.

In *Irreducible*, a series of photographs of pedestrian structures, Gilad Ophir suggests the acceleration of the urbanizing process in Israel as it affects the landscape. In *Shopping Center, Kibbutz Gan-Shmuel*, Ophir offers the viewer images of a suburban strip mall that attest to the rapid incursion of wealth in a region that was once defined by great expanses of uninhabited terrain (fig. 5). In Orit Siman Tov's series of photographs of Israelis partaking in leisure-time activities, the mall is viewed as a vast canyon where distractions relieve everyday stress (fig. 6).

In Yaron Leshem's fifteen-foot-long light-box work *Village*, the artist undermines our assumptions about the veracity of a landscape photograph (pl. 8). This panorama initially appears to be a benevolent view of a Palestinian village nestled in a hillside. Upon closer inspection, the viewer becomes aware that, as the artist has said, "every detail in the village has a military meaning that has replaced the initial functioning meaning."[12] In fact, *Village* depicts an Israeli Defense Force training camp with false building facades and painted figures depicting lifelike activities. During his military service Leshem trained in sham villages such as this. Leshem's version of a Potemkin village is composed of fifty digital photographs merged seamlessly into a single image, showing how photography can be manipulated to shape public opinion. Thus a seemingly innocent rural scene can hide a far different reality—a location that was carefully chosen as the scene of full-scale war exercises.

6. **Orit Siman Tov** (Israeli, b. 1971), *Mall Hazahav Rishon LeZion*, 1996. Chromogenic print, 15¾ × 23⅜ in (40 × 60 cm). Collection of the artist

Current Events and Critical Perspectives

A far-ranging body of photography and video art in Israel addresses the difficulty of receiving and processing the overwhelming mass of information transmitted through print, TV, and the Internet. Motti Mizrachi turns the news photograph on its head in *Blinking,* manipulating and distorting images as he transforms fifteen hundred photographs of the second intifada from the newspaper *Ha'aretz.* He covers the year from the beginning of the Al-Aqsa Intifada in 2000 until the attack on Manhattan's Twin Towers twelve months later, creating a semiabstract work suggesting a scene one might see from a window at high speed (pl. 10). Mizrachi suggests that the overabundance of news reports in Israel clouds our ability to process current events because our consciousness is flooded by information. As the artist noted when *Blinking* was first shown in Israel, "The information given to the public through the various channels of the media acts like a screen." By employing the excess of media images to create a work of art, Mizrachi can obscure the harsh contents seen originally in the news. Thus the material is blurred, leaving us in a state of "blinking." Only with intense scrutiny can actual images be discerned within the patterned, abstract surface.

In a culture saturated by mass media, a central problem for socially oriented artists is how to reconnect images with reality. It is as if a steady diet of filmed and televised violence inures most people to scenes of genuine horror. Michal Heiman turns this paradox to dramatic effect in *Blood Test* and in *Holding Series,* which draws on news photography to make a powerful statement about violence (fig. 7). In *Blood Test* the artist uses enlarged photographs of bloody body parts that she has gathered from newspapers found in the national archives, selecting only details that cannot be identified with any individual victim (pl. 11). Though she did not take the photographs herself, she manipulates them so that they lose their individual identity. The anonymity of these images is stressed through the cold clinical data provided by the chart at the top of the pieces, which emphasizes the randomness of the images. Photographs of this nature appear frequently in the Israeli press and, when shown out of context and assembled in this manner, can seem in a macabre sense like elements in an artistic composition.[13]

Just as Michal Heiman confronts the viewer with uncomfortable aspects of Israel, the artist Ahlam Shibli makes photographic narratives that penetrate what she refers to as the invisible life of her people, the Bedouin.[14] In one scholar's view, Shibli's "created 'placescapes' function as places in memory and as powerful tools to mobilize political passions."[15] Difficult realities are also at the heart of the work of Palestinian-American artist Emily Jacir, whose

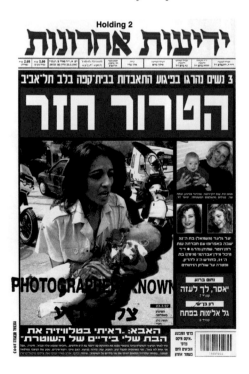

7. **Michal Heiman** (Israeli, b. 1954), *"Holding 2," Photographer Known— Michael Kremer, Tel-Aviv, Ha'aretz Daily Newspaper, 03/06/2001,* from *Holding Series (Gone with the Wind),* 2001–5. Print on canvas, 67⅜ × 47¼ in. (171 × 120 cm). Andrea Meislin Gallery, New York

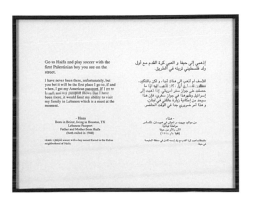

8. **Emily Jacir** (Born Bethlehem 1970), *Where We Come From (Hana)*, 2001–3. Framed laser print and chromogenic print mounted on cintra, text 9¼ × 11½ in. (24 × 29 cm); photo 15 × 20 in. (38 × 50.8 cm). Alexander and Bonin, New York

9. **Kobi Israel** (Israeli, b. 1970), 0459 (from the series *Fragments of Life*), 2001. Chromogenic print, 39⅜ × 31½ in. (100 × 80 cm). Collection of the artist, Tel Aviv

photography and accompanying texts have been defined by the Israeli-Palestinian conflict. Having exhibited her work internationally, Jacir seeks to communicate her experiences as someone able to move about freely between two worlds. In her projects, Jacir assumes the role of a surrogate for exiled Palestinians who, because of security and political exigencies, are unable to carry out various activities (fig. 8). For example, in her series *Where We Come From*, the artist asks, "If I could do anything for you, anywhere in Palestine, what would it be?" Jacir then based her photographs on the responses that she received. By openly confronting, and then documenting, the lives of Palestinians, Jacir exposes us to their daily struggles.

In Israel, where existential uncertainty prevails and a broad spectrum of opinions is the norm, controversy seems endemic to art. Often, as in the work of Kobi Israel, a photograph's success can by measured by its ability to engage the viewer with provocative imagery (fig. 9). Curator Nissan N. Perez has written that this artistic attitude is characterized by the courage to express contentious opinions; in his view, artists in Israel view being militant and politically incorrect as their "prime duty."[16]

Real Life in Real Time

For the artists Amit Goren, Yael Bartana, Miki Kratsman, and Boaz Arad, video offers the opportunity to present life in Israel in real time, with images and sound that capture multiple perspectives.[17] The ultimate goals of these artists and others are to critique and shape Israeli political and social systems. Goren's video *Map* employs six independent videos of identical length, presented on monitors in a hexagonal arrangement (pl. 9). The simultaneous projection of multiple narratives suggests random associations. Offering a kaleidoscope of images, snatches of dialogue, and an elaborate mix of soundtracks, Goren's camera encompasses sites as disparate as Tel Aviv, New York, Cairo, Paris, Los Angeles, the Mongolian plateau, the Golan Heights, and the Jordanian-Israeli border, transforming these places into unspecified, transitory locations. As an Israel-born artist who has spent considerable time in the United States, Goren explores his personal sense of dislocation in a world torn by sectarian strife. The diverse themes projected simultaneously in *Map*—Goren's family history, his personal and professional life, the lives of Palestinian refugees, moments in Israeli history, and the experiences of Mongolian nomads—dramatically underscore the artist's complex and deeply personal statement about international issues of displacement and geographical conflict.

For her video *Trembling Time,* the Israeli artist Yael Bartana placed her camera at an elevated vantage point overlooking a highway running through Tel Aviv during the countrywide sounding of the siren and the moment of silence commemorating Israel's fallen soldiers and victims of war on Yom Ha-Zikaron (Day of Remembrance) (pl. 12).[18] In Bartana's view, this national activity provides a means to examine the power of the state over society.[19] In *Trembling Time,* the artist prolongs the moment when all activity comes to a halt, allowing the viewer to experience the memory-

laden ritual as an aestheticized experience. As Israeli citizens in the video respond to this social-cultural event, cars and passengers in motion create ghost images in the eerie silence. Drivers and passengers are frozen in a stance that encourages remembrance while also imitating the military posture of standing at attention in front of the flag. This national activity prompts us to consider the power of ritual in Israeli society, and the artist raises questions about the individual who feels obligated to follow state-sanctioned conduct.[20]

In their forty-minute film *Untitled,* made by Boaz Arad and Miki Kratsman in 2003 at the Erez checkpoint on the border between Israel and the Gaza Strip, the artists focus their camera on a continuous stream of Palestinian laborers making their way home after a day of work in Israel (pl. 16). Some carry food, others toys for their children, but none remains in our vision long enough to be examined closely. The procession of men with their bundles is only one layer of the story. The absence of commentary highlights the men's anonymity, forcing viewers to confront the dehumanizing experience of checkpoints in the lives of Palestinians.

Icon of Separation

The local issue of physical division between Israelis and Palestinians long ago entered the realm of international discourse. Israel's separation barrier has become an architectural icon—not merely a geopolitical statement—and is now subject to scrutiny by the whole world.[21] As Jerusalem's former deputy mayor said, "Perhaps for some Israelis the premise of separation can be rationalized, but in so doing an idea that to ordinary people would seem insane, begins to seem logical in Israel."[22] Political considerations are entwined with the architectural agenda and this new barrier between Israel and the areas under the Palestinian Authority. The barrier, most of which is in the form of a fence, has become part

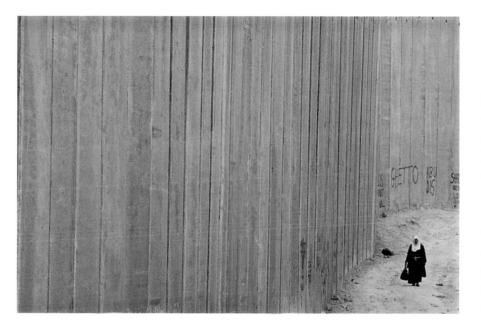

in her film *Wall*, because, in her words, "the wall is built with modernist-looking concrete blocks, which could resemble a Richard Serra sculpture. They can start to look quite beautiful—that's really frightening. The work is sculptural and spatial as well as temporal."[23] Yass filmed a portion of the wall from the Israeli side using Super-16mm film to convey the physicality of the barrier as it winds through communities and stretches across the landscape (pl. 13). In a larger sense, the wall made the artist think about the "emotional barriers that arise between individuals. For me, it is a physical manifestation of people's inability to

10. **Miki Kratsman** (Israeli, b. Argentina 1959), *Abu Dis*, 2003. Digital print, 47¼ × 70⅛ in. (120 × 180 cm). Chelouche Gallery, Tel Aviv

11. **Shai Kremer** (Israeli, b. 1974), *Defense Wall surrounding Gilo neighborhood, Jerusalem 2004*, 2004. Digital chromogenic print, 27 × 32 in. (68.6 × 81.3 cm). Collection of the artist

of the regional landscape and a reflection of Israel's approach to reducing the terror and violence that emanated from Gaza and the West Bank. Unsurprisingly, both Israeli and non-Israeli artists have been drawn by the enormous height of the wall. Miki Kratsman, Shai Kremer, English artist Simon Norfolk, and German artist Kai Wiedenhöeffer have photographed similar locations in Jerusalem; Kremer, Kratsman, and Norfolk, each imagine the landscape on the far side of a particular section of the wall, as if it were possible to see forms through concrete (figs. 10, 11).

In fact, the British artist Catherine Yass found it difficult not to aestheticize the subject of the barrier

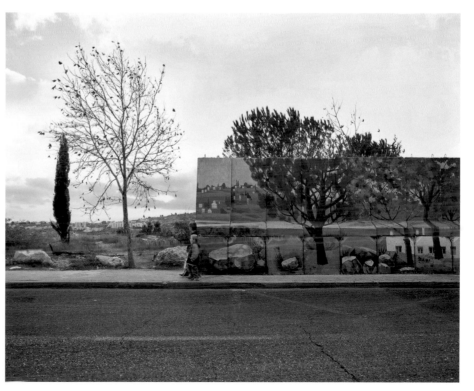

see around corners and negotiate their way past blockages."[24] In *Wall*, the artist offers distant views with glimpses of the landscape and architecture beyond the barrier, as well as those that are close up, when the wall is the only thing in sight and the focus is on textures in the concrete. By limiting the viewer's field of vision, the artist's perspective becomes a comment on the restricted outlook on both sides of the Israeli-Palestinian conflict.

Palestinian photographer Noel Jabbour believes that the barrier has dire consequences for both Palestinians and Israelis. Directly addressing the issue of territoriality, her artful response is a photographic triptych with views from the inside and the outside of the wall as it appears at Abu Dis (pl. 14).[25] The triptych gives us a sense of the winding and curvilinear nature of the wall—at Abu Dis it passes right through town, dividing Palestinian families and communities. Catherine Yass commented on this aspect while researching her video: "I realized that it is not easy to know which side you are on. . . . [My video] shows the wall winding to such a degree that you lose track of which side of it the camera is filming from."[26] Jabbour herself believes that the wall is an "expression of the total failure of the Israelis and the Palestinians to share the ground . . . and live peacefully side by side."[27]

Confronting Conflict with a Camera

The strategies used by artists are often deployed by photojournalists, who have produced some of the most powerful images of present-day Israel. Four notable Israeli photojournalists—Pavel Wolberg, Rina Castelnuovo, Miki Kratsman, and Natan Dvir—have insinuated themselves into the Israeli-Palestinian conflict to document the human cost of political strife. Frequently, photography originally intended as photojournalism finds its way into galleries and museums, as in the case of Wolberg's solo exhibition in 2002 at the Tel Aviv Museum, which included haunting images of the military situation.[28] As an intrepid chronicler of the contradictions inherent in Israel today, Wolberg responds to intense moments of human paradox, and he has evolved a style that enables him to dissect the conflict with uncommon sensitivity (fig. 12). The artist shows eloquently what animates Israeli society: a vitality and a sadness, a need for normalcy and an understanding that nothing is normal. His photographs, which are not staged, transform seemingly straightforward situations into symbolic moments (pl. 19).

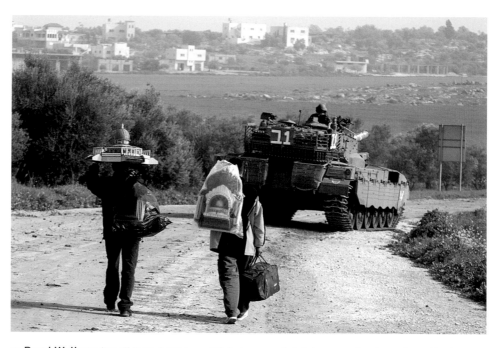

12. **Pavel Wolberg** (Israeli, b. Soviet Union 1966), *Jenin*, 2004. Digital chromogenic print, 19¾ × 27½ in. (50 × 70 cm). Dvir Gallery, Tel Aviv

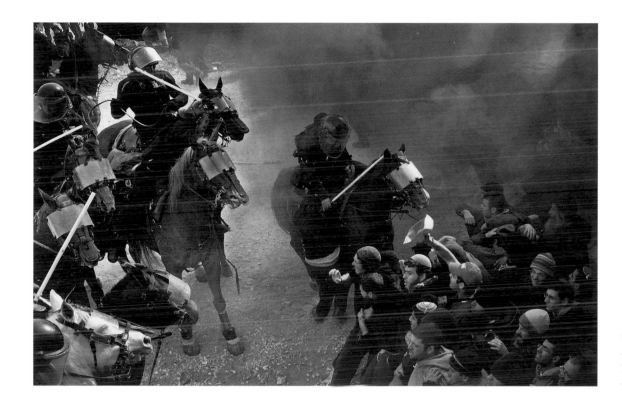

13. **Rina Castelnuovo** (Israeli, b. 1956), *Amona, West Bank,* 2006. Chromogenic print, 30 × 40¼ in. (76.2 × 102.6 cm). Andrea Meislin Gallery, New York

In confronting the tensions in the region, Rina Castelnuovo has similarly evolved a style that probes the human reality behind the political facade. As a witness to two decades of conflict, she is familiar with its nuances and dilemmas. Working under exceptionally difficult circumstances on assignment for the *New York Times,* her photographs of breaking news often contain multiple narratives within a single picture (fig. 13). Castelnuovo's intention is to be as unobtrusive as possible; her compassion is evident in the private moments in which her subjects rarely look at the camera, unaware of her presence (pl. 18). Thus she captures the humanity and spirituality present in places ranging from army bases to Israeli settlements, and in doing so, as a photography edi-

tor at the *New York Times* has said, "She keeps her soul in the picture."[29] Miki Kratsman, in still images like *Christian Couple* and *Old Couple in Dahaisha Refugee Camp, Bethlehem,* has created icons of dignity and suffering (pl. 20). As testaments to human forbearance, they have a strong emotional tone and an underlying political viewpoint. Both photographs make use of traditional conventions of portrait photography: the images of the Christian couple, whose slain daughter is pictured on the wall behind them, and the Muslim couple in a refugee camp represent the raw, painful reality of life in Israel and the territories. In a powerful series of photographs on the disengagement from the Gaza Strip in 2005, Natan Dvir documented the response of Jewish settlers

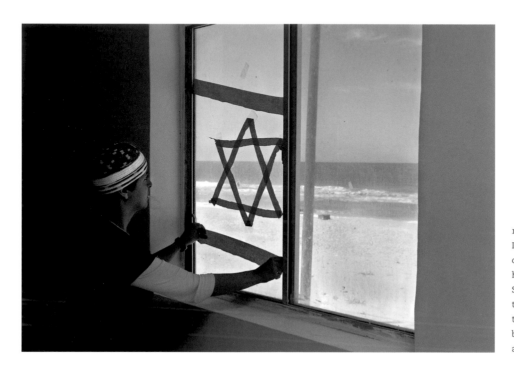

14. **Natan Dvir** (Israeli, b. 1972), *Shirat HaYam, May 2005*, 2005. Digital chromogenic print. 18¼ × 27½ in. (47 × 70 cm). Collection of the artist. Artist's caption: "Israel Jewish settler Maggie Peretz hanging blue strips in the formation of the Israeli flag on the Shirat HaYam synagogue's window as part of the preparations toward the Israeli independence day. Shirat HaYam was one of twenty-one Jewish settlements, part of Gush Katif settlements bloc in the Gaza Strip, which were evacuated during August 2005 as part of the Israeli disengagement plan."

being forced to relocate. While some of his images capture the dramatic confrontations between Israeli soldiers and the settlers, others are more reflective and intimate, such as *Shirat HaYam,* in which an evicted settler marks her synagogue with an improvised Israeli flag (fig. 14).

Moments in the Life of a Nation

At the core of Barry Frydlender's photographs, including *The Flood* and *The Blessing,* are ideas about the aesthetics of time. Both works are composed of numerous digital photographs, all taken from the same vantage point, that Frydlender spliced into a unified image. We see landscapes and interiors as they appear in the world but inhabited by figures and objects that never actually stood side by

side.[30] *The Flood* (fig. 15) depicts the pooling of water after an intense rainstorm in Tel Aviv and the attempts to cope with the aftermath, alluding to the episode in the Hebrew Bible in which God inundated the earth to cleanse it of humanity's sins in order to start the world anew. In his large-format digital photo *The Blessing* (pl. 21), the artist shows a gathering of ultra-Orthodox men and boys on the holiday Lag Ba-Omer in a rustic picnic area in the lower Galilee. Within this panoramic view of a rural outing, some of the individual figures appear several times, the shifting angles of their shadows the only indication of the different times at which the pictures were taken. *The Blessing* enlivens a common discordance found in Israel and elsewhere—the incongruity of present-day ultra-Orthodox men in their eighteenth-century garb with cell phones and other modern conveniences.

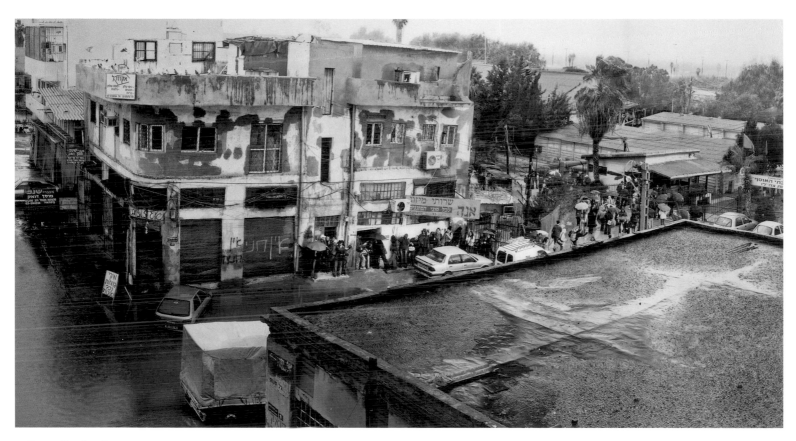

15. **Barry Frydlender** (Israeli, b. 1954), *The Flood*, 2003. Digital chromogenic print,
49¼ × 90½ in. (125 × 230 cm). The Jewish Museum, New York, Artex Purchase: William
and Jane Schloss Family Foundation Gift, 2005–12

16. **Beat Streuli** (Swiss, b. 1957), *Tel Aviv 99*, 1999. Edition of three, color photograph, 59½ × 78¾ in. (151 × 200 cm). Murray Guy Gallery, New York

The individual within an urban setting is the subject of Leora Laor's photography. Like the work of the Swiss artist Beat Streuli, who has chosen his subjects randomly from the stream of passersby on the streets of Tel Aviv (fig. 16), the images made by Laor capture the ambience of the ultra-Orthodox neighborhood of Mea She'arim in Jerusalem (pl. 24). The images are blurred and manipulated with digital technology, disarming the viewer with their elusiveness. Yet these photographs are clearly situated in reality, and Laor's depictions reveal the intimacy and diversity that characterize moments in the life of this insular community. The aim is to show familiar scenes, but in an oblique fashion, creating grainy yet luminous pictures of figures who appear evanescent within their traditional setting. With a remarkable sense of restraint the artist has mediated between the inner, spiritual world

found in this Orthodox neighborhood and the surrounding secular environment.

Community is also at the root of Reli Avrahami's highly saturated color photographs in her series *The Flower Sellers*. As explained in the artist's captions, these works depict recently arrived immigrants from the former Soviet Union who are forced out of need to sell flowers on the highways of Tel Aviv (fig. 17). Exposed to the elements, these young people provide a glimpse into the difficult situation confronting many immigrants to Israel, who form a high percentage of Israel's working poor.

The intertwining of personal and local issues with global concerns is explored by Gillian Laub, an American photographer who depicts young Israelis and Palestinians. Laub believes that the Israeli-Palestinian conflict has resulted in so many words and

images that "people have become dehumanized objects, statistics, and the repository of abstract cliches."[31] In order to connect with Israel in a personal manner, Laub began her project by traveling throughout Israel and the occupied territories. By presenting quotations from her subjects with the photographs themselves, she transmits their voices as they speak to their common concerns, particularly with respect to personal and national identity (pl. 15). In Laub's view, "this conflict . . . is so layered and complex" that "there is no good or evil side. . . . I have discovered a shared pain, a strong will to survive, and a lot of compassion from all sides."[32] In fact, the outward appearance of each sitter is so similar that we become aware that it is necessary to read the captions in order to determine who is Israeli and who is Palestinian (see Grundberg essay, figs. 12, 13).

Works that capture the most apparently innocent aspects of daily life may encode more nuanced messages, as in Orit Raff's photographs made in an Israeli bakery. In her project called *Insatiable,* which depicts aprons, an oven, and various materials used in the preparation of bread, Raff explores the confluence and contradiction embedded in the Hebrew words for bread and war. *Lehem* (bread) and *milhama* (war) are linked by their common Hebrew root (ל.ח.מ), suggesting the tension between life and war. The artist's concern for personal and social survival is at the root of her images. Each photograph in *Insatiable,* whether of stained aprons, burnt and empty baking trays, or an oven, is redolent with associations. It is difficult not to seize on the Holocaust implications in the striking image of an antique oven from Eretz Israel (pl. 17), and one can detect traces of human presence in the stains that remain on the aprons and in the knife marks left on the discolored trays.

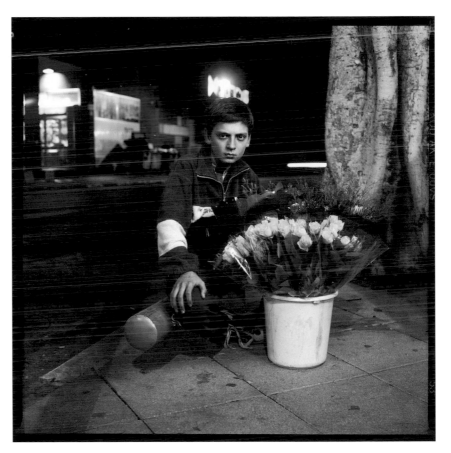

17. **Reli Avrahami** (Israeli, b. 1960), *Flower Seller,* from *The Flower Sellers* series, 2002. Chromogenic print (from Ektachrome slide), 24⅛ × 23⅛ in. (63 × 60 cm). Collection of the artist. Artist's caption: "Oleg Grushev, 13 years old, immigrated from the Ukraine, 3 years ago, in Nordau Blvd., Tel Aviv, February 2002."

Life Armed and Unarmed

At the heart of some artists' work is a question that confronts Israelis today more than ever: How does a person negotiate the ongoing clash between a community ethic and the needs of the individual? For years Israeli society valued its collective identity above and beyond any private, personal aspirations. Since the aftermath of the Yom Kippur War (1973) and the invasion of Lebanon in 1982, Israelis have increasingly come to value the irreplaceable individuals at least as much as the land they died defending.[33] The continual interplay between the individual and the collective has left its imprint on the work of the European photographers Rineke Dijkstra and Wolfgang Tillmans, for whom the universal military draft in Israel has had particular resonance.[34]

Dutch artist Rineke Dijkstra made formal photographs of young Israeli men and women at the beginning of their military service, photographing at local induction centers and at home in civilian dress (see Grundberg essay, figs. 18, 19). These portraits, made at crucial moments of transition, vividly depict the differences in posture and facial expression prompted by social roles. Through their poses, gestures, and gazes, the soldiers betray the tension between power and vulnerability, military prerogatives and individual needs. Although the artist possesses a detached, unflinching eye, she imbues her portraits with empathy and restraint (pls. 22, 23).

Tillmans was drawn to many subjects in Israel, from the urbanscape of Tel Aviv to ordinary household items to a young solider named Shay. Using a snapshot aesthetic—a seemingly casual approach to portraiture that is carefully staged—Tillmans created a brief photographic essay in which the armed Shay is first seen in a hallway before entering a bedroom (fig. 18). In the second and third images, his posture is guarded and his hand is on his rifle, with a finger near the trigger. Is the soldier securing a danger-

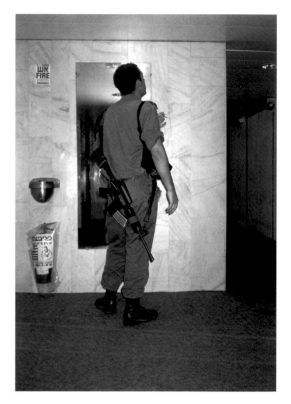

18. **Wolfgang Tillmans** (German, b. 1968), *Shay, Shay II, Shay III, Shay IV*, 2002. Four chromogenic prints, each 16 × 12 in. (40.6 × 30.5 cm). Andrea Rosen Gallery, New York

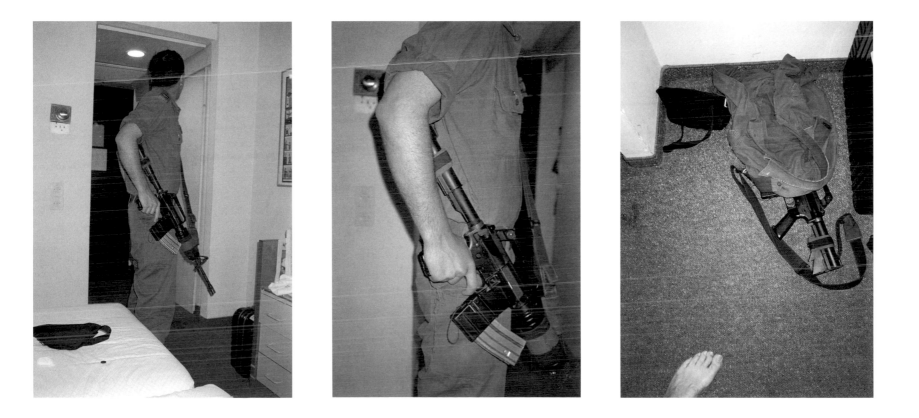

ous location? Or is he merely returning home after his workday? In the final photograph, Shay has shed his uniform, and the viewer can see his naked foot in the foreground. By concluding the series with his discarded military garb, the artist confronts the stereotype of the powerful Israeli soldier with an image that stresses his vulnerability.

Like seismographs, all of the artists discussed here are intensely sensitive to the shifting social order in Israel. As they gauge the fissures and tremors of Israeli society, they ponder the underlying forces of a country often in conflict These artists seek to unsettle the viewer as they probe beneath the surface. They not only push aesthetic boundaries, they also suggest that a multiplicity of artistic approaches is required to reveal the tangled, elusive reality of Israeli society. For many of these artists, the Zionist dream as originally conceived must be confronted and, ultimately, adapted to the reality of a still-evolving nation.

plates

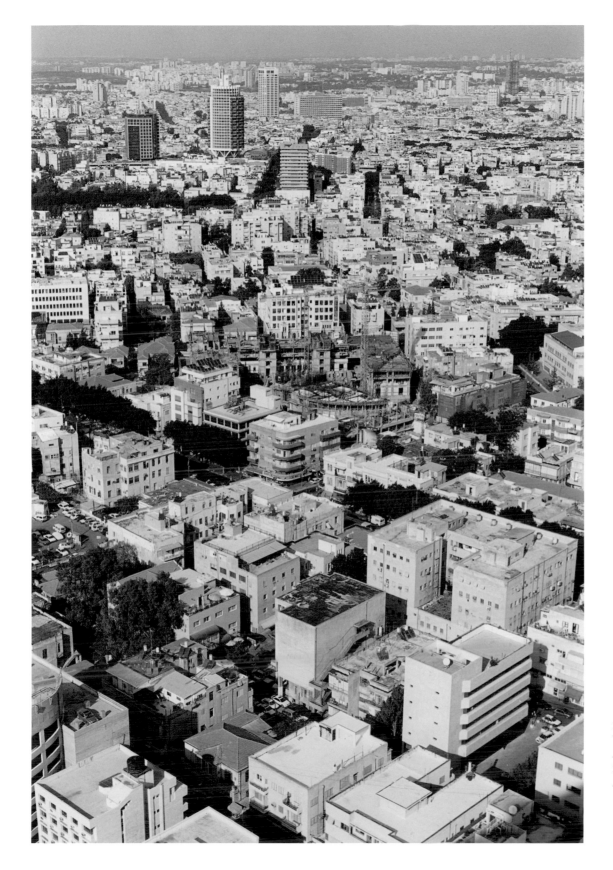

Plate 1
Wolfgang Tillmans (German, b. 1968)
Aufsicht (yellow), 1999
Ink jet print, 102 × 70 in. (259.1 × 177.8 cm)
Andrea Rosen Gallery, New York

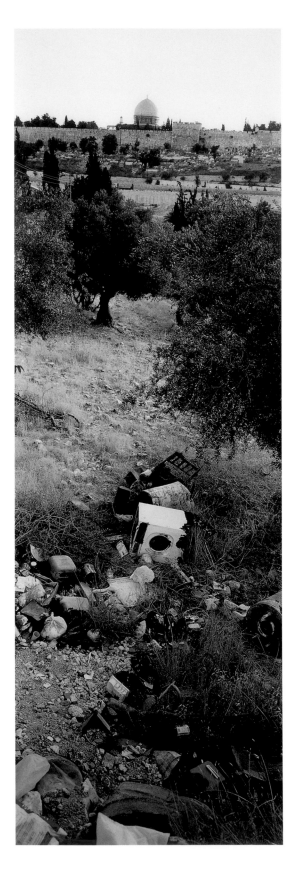

Plate 2
Wim Wenders (German, b. 1945)
Jerusalem Seen from the Mount of Olives, 2000
Chromogenic print, 114⅛ × 45⅞ in. (289.9 × 116.5 cm)
The Jewish Museum, New York, Purchase: Photography Acquisitions Committee Fund and Alice and Nahum Lainer Gift, 2004–62

Plate 3
Sharon Ya'ari (Israeli, b. 1966)
Cypresses, 2001
Chromogenic print, 50¼ × 63 in. (127.5 × 160 cm)
The Jewish Museum, New York, Purchase: William and Jane Schloss Family Foundation Gift, 2006–43

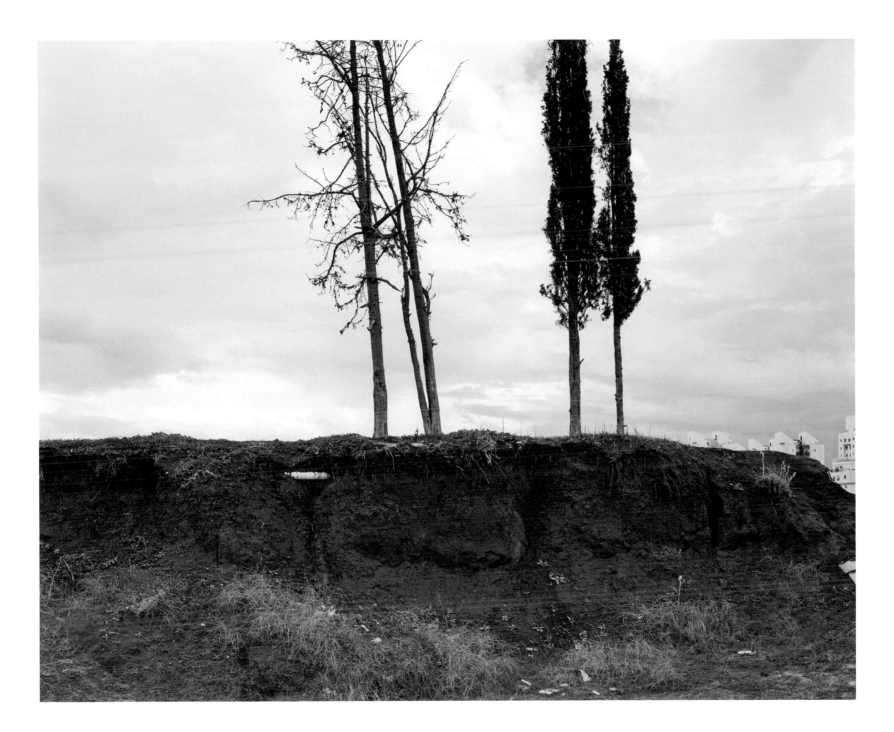

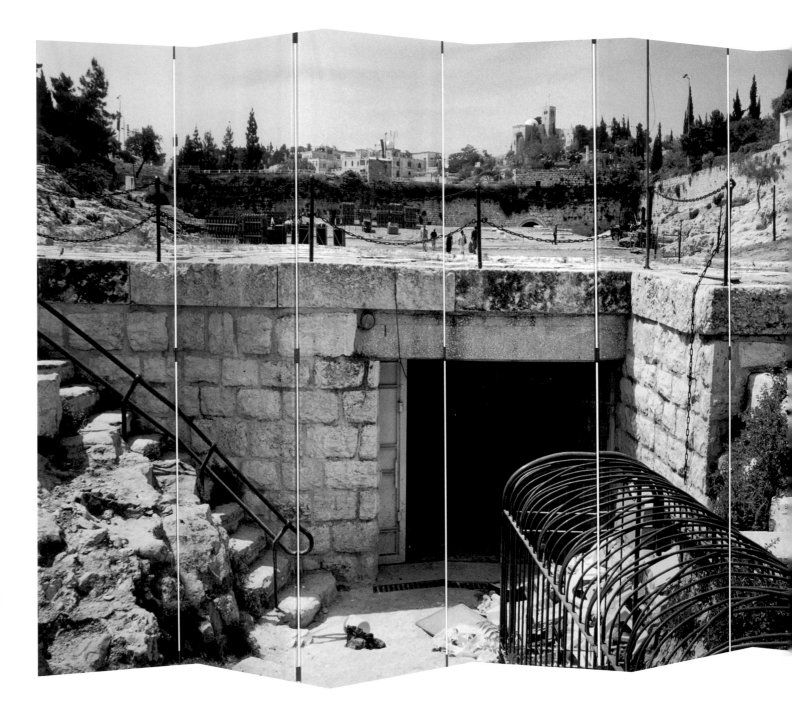

Plate 4
Mark Wallinger (British, b. 1959)
Painting the Divide (Jerusalem), 2005
Digital print on canvas, on two six-panel folding screens, each 94½ × 191 × 17¾ in. (240 × 485 × 45 cm)
Galerie Krinzinger, Vienna

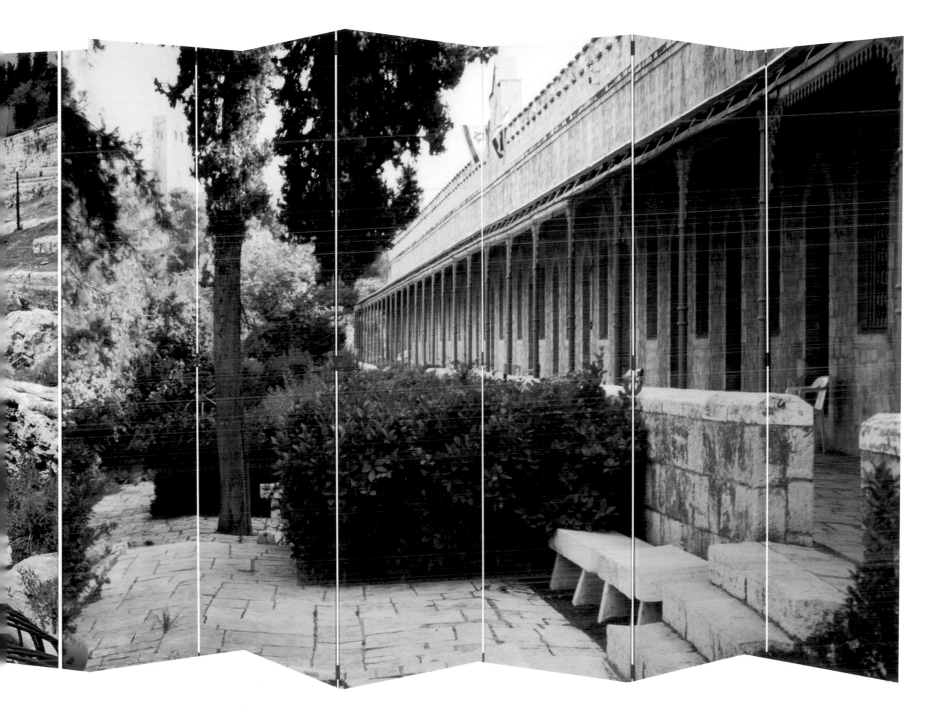

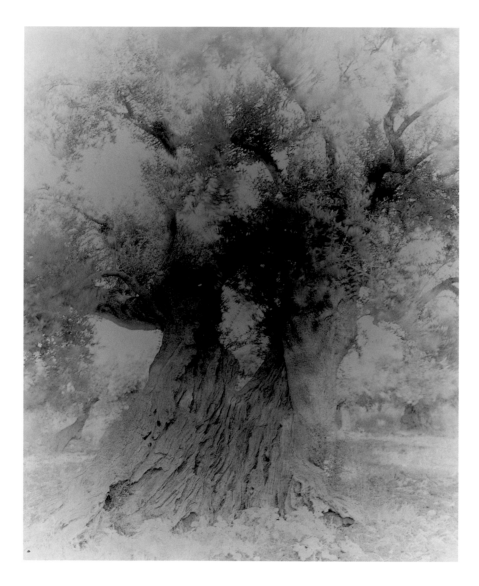

Plate 5
Ori Gersht (Israeli, b. 1967)
Ghost-Olive No. 1, 2003
Chromogenic print mounted on aluminum,
40¼ × 33¼ in. (102.2 × 84.5 cm)
Collection of Thomas H. Lee and Ann
Tenenbaum, New York

Plate 6
Igael Shemtov (Israeli, b. 1952)
Landscape with Castor Oil Plant #10, 1999
Chromogenic print, 50 × 59⅛ in. (127 × 150 cm)
The Israel Museum, Jerusalem; Purchase
through Marion and Guy Naggar Fund, London

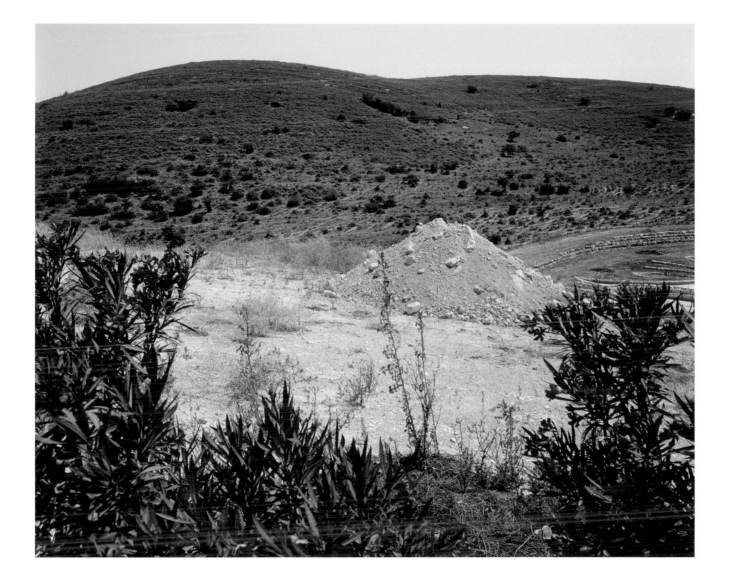

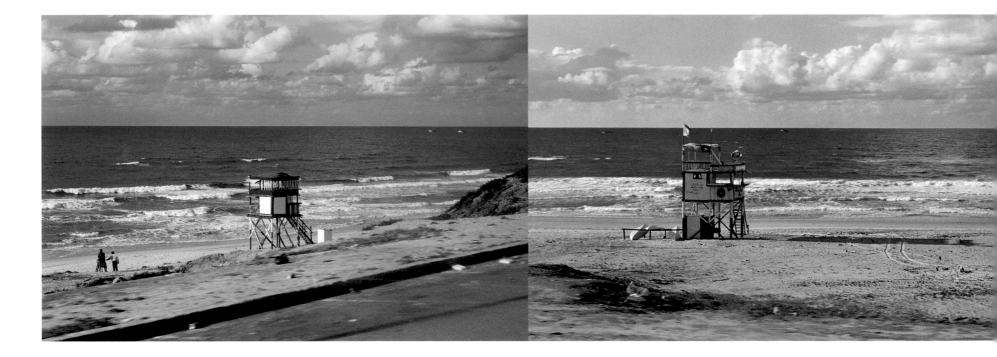

Plate 7
Guy Raz (Israeli, b. 1964)
Lifeguard Towers—Serial 1, 2003
Chromogenic print, four works;
each 22¼ × 31⅞ in. (56 × 81 cm)
Nelly Aman Gallery, Tel Aviv

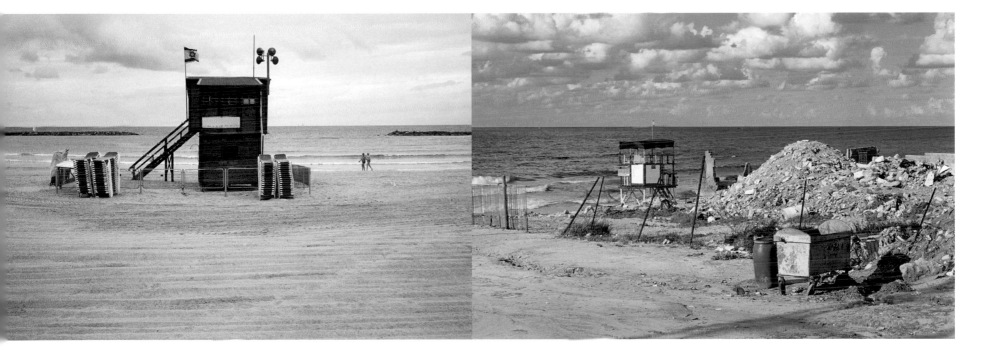

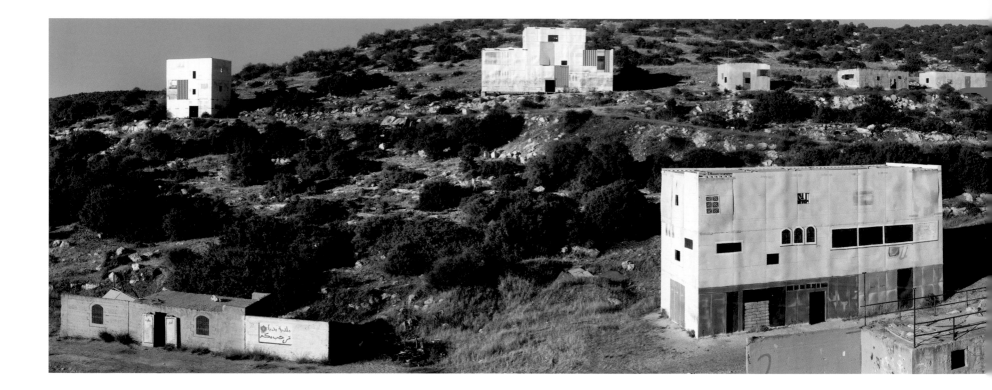

Plate 8
Yaron Leshem (Israeli, b. 1972)
Village, 2004
Digital chromogenic print laminated
on Plexiglas mounted on a light box,
35¾ × 185 in. (91 × 470 cm)
Courtesy of the artist, New York

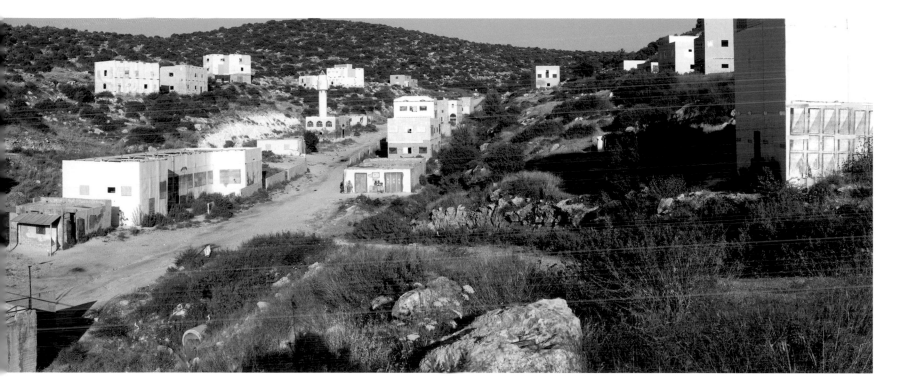

Plate 9
Amit Goren
(Israeli, b. 1957)
Map, 2003
Six-channel video
installation, 8 min.,
28 sec.
Collection of the
artist, Tel Aviv

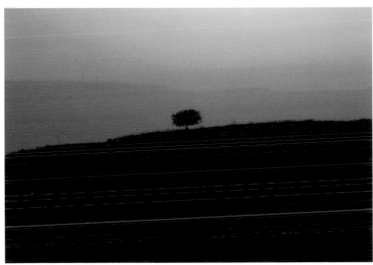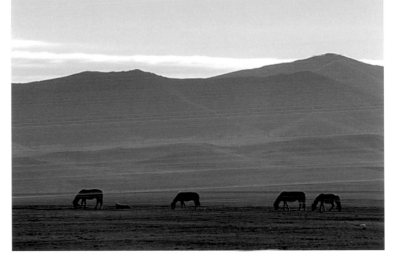

Plate 10
Motti Mizrachi (Israeli, b. 1946)
Blinking, 2000
Digital print on canvas, triptych;
each 45⅛ × 31½ in. (115 × 80 cm)
Chelouche Gallery, Tel Aviv

Plate 11
Michal Heiman (Israeli, b. 1954)
Blood Test (detail), 2002
Digital chromogenic print mounted on aluminum,
triptych; each 20½ × 40 in. (52.1 × 101.6 cm)
The Jewish Museum, New York, Purchase: Sylvia
Monaghan Bequest, 2003–28.1–3

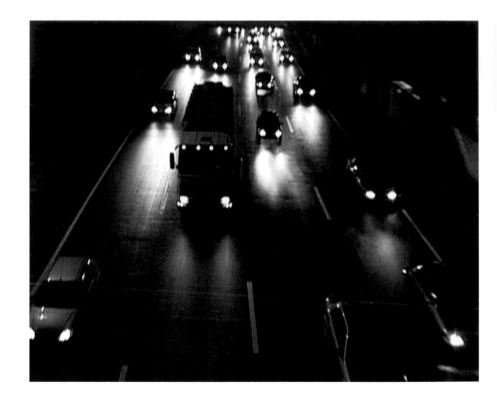

Plate 12
Yael Bartana (Israeli, b. 1970)
Trembling Time, 2001
Video installation, soundtrack by Tao G. Vrhovec
Sambolec, 6 min., 20 sec.
The Israel Museum, Jerusalem; Purchase through
Artvision Acquisition Committee, Israel

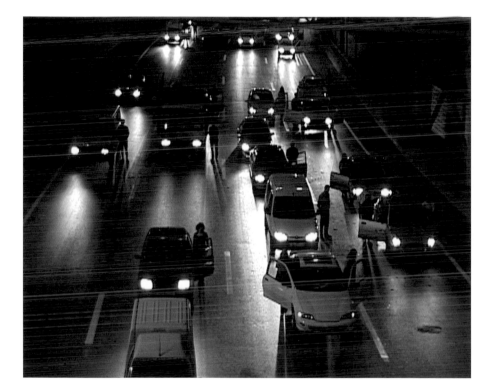

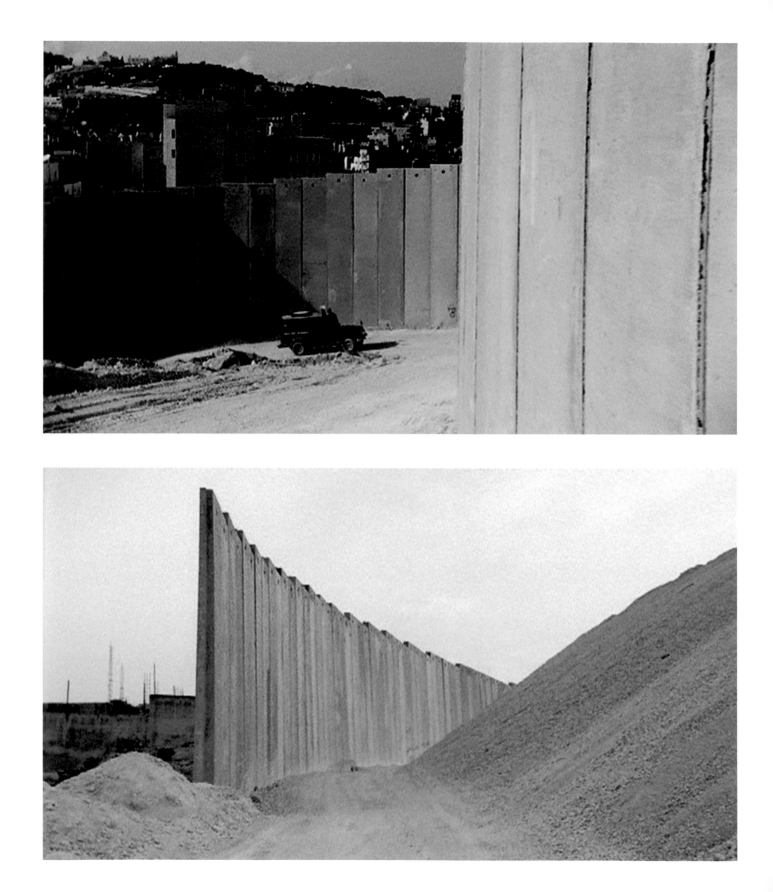

Plate 13
Catherine Yass (British, b. 1963)
Wall, 2004
Video installation, 32 min., 50 sec.
Alison Jacques Gallery, London

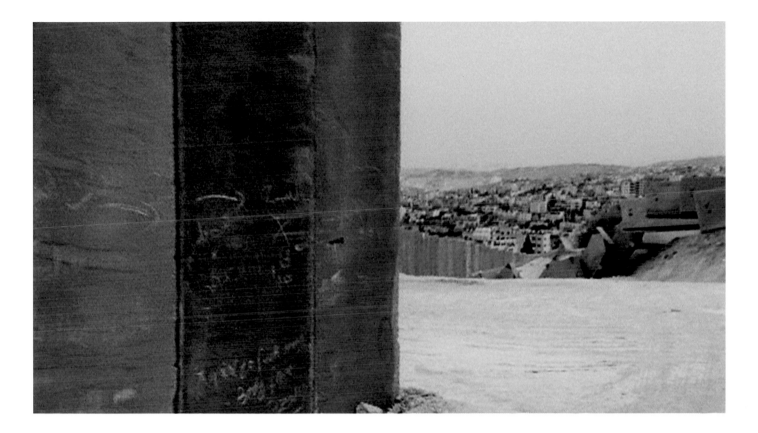

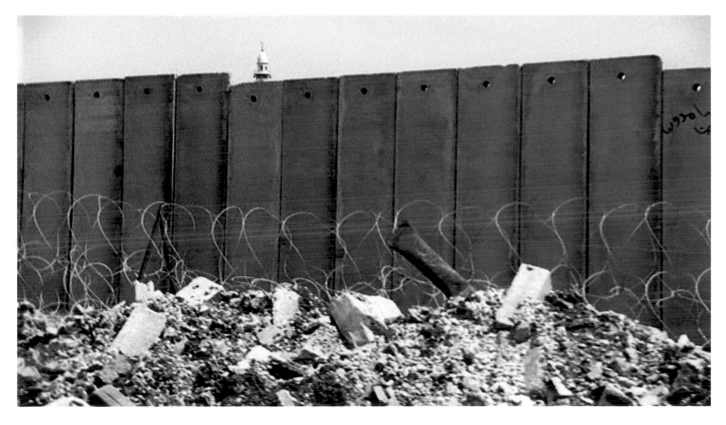

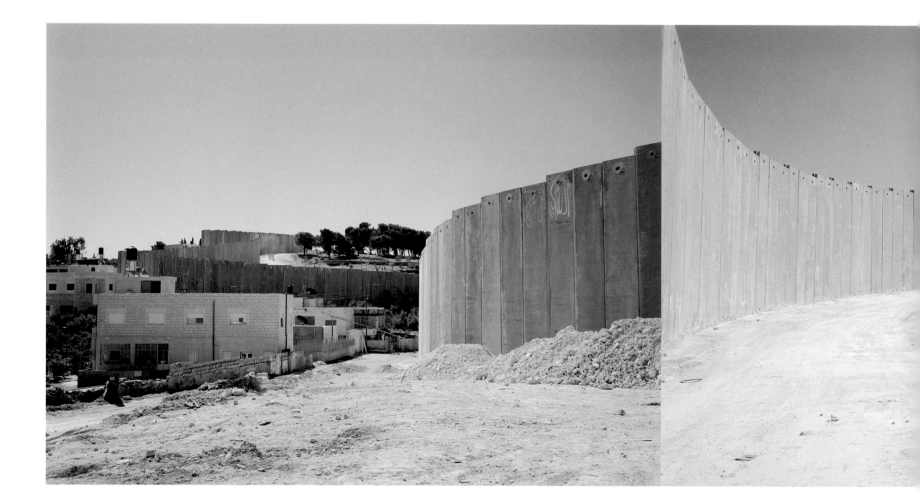

Plate 14
Noel Jabbour (Palestinian, b. 1970)
Abu Dis Wall, 2004
Digital print mounted on aluminum,
30 × 101 in. (76 × 256 cm)
Loushy Art & Editions, Tel Aviv

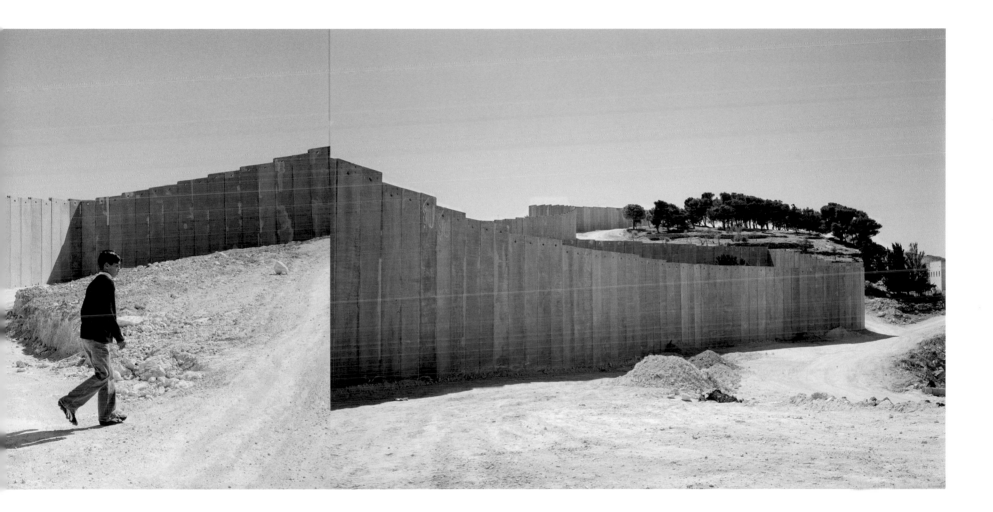

Plate 15

Gillian Laub (American, b. 1975)

Guy and Ranit, Arad, Israel, 2003

Chromogenic print, 30 × 40 in. (76.2 × 101.6 cm)

Courtesy of the artist and Bonni Benrubi Gallery, New York

Guy: "For the past two years I served in the paratroopers support unit. [Last year] the jeep I was in passed over a very powerful road bomb. My legs were amputated from below my knees. I feel lucky to be alive. Seven months from the day I was wounded . . . I am happy, strong, and healthy, both physically and mentally. I believe that we all have an extreme internal power that is released only in these situations. This is why my condition is better now than when I actually had legs. But I do have a friend Louie. He is from a Northern Druse village [the only non-Jews/Arabs besides Bedouins who can serve in the Israeli army]. We both began our army service on the same day and got injured at the exact same time in totally different locations. Life has a funny way of working . . . we ended up in the hospital together, both with no legs. The only difference between us is that I have my knees so I can wear prosthesis to walk and do just about everything. I think Louie is having a harder time. I truly do not feel any animosity towards the other side. I understand the suffering they are going through. After all, we are really brothers."

Ranit: "When I heard Guy was injured, I went straight to the hospital. We grew up in the same small town [comprising mostly families from Morocco], but I hadn't seem him in years. I had a big crush on him in high school, but I couldn't do anything about it because he went out with a friend of mine. I was so nervous to visit him. The moment I saw Guy, I realized I was still in love with him. We have been together since. He is so strong, in his body, mind, and spirit. I am amazed by him every day. Our favorite thing to do is go riding in his jeep through the beautiful desert [in the photo]. I will have to go to the army next year, but I know they will take care of me because I am Guy's girlfriend."

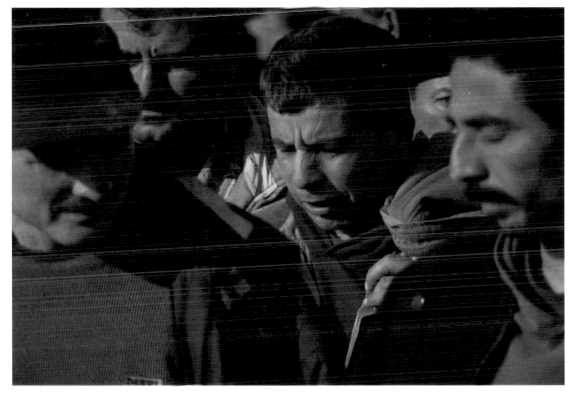

Plate 16
Boaz Arad (Israeli, b. 1956) and
Miki Kratsman (Israeli, b.
Argentina 1959)
Untitled, 2003
Video installation, 40 min.
Collection of the artists, courtesy
Chelouche Gallery, Tel Aviv

65

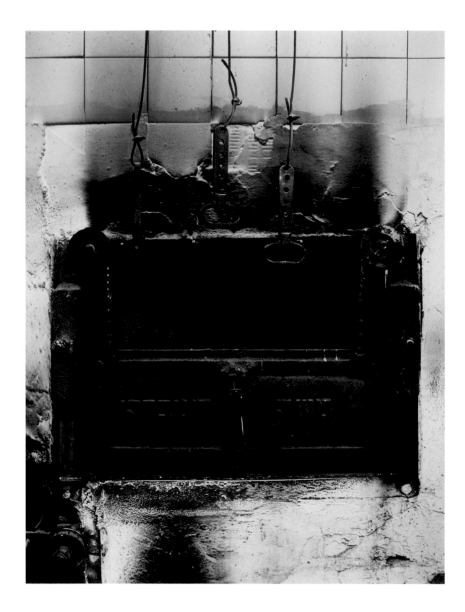

Plate 17
Orit Raff (Israeli, b. 1970)
Untitled (Oven) (from *Insatiable* series), 2001–4
Chromogenic print, 34 × 29 in. (86.4 × 73.7 cm)
Courtesy of the artist and Julie Saul Gallery, New York

Plate 18
Rina Castelnuovo (Israeli, b. 1956)
Migron Outpost, West Bank, Hanukkah 2004
(from the *Settlers* series), 2005
Chromogenic print, 30 × 40 in. (76.2 × 101.6 cm)
Andrea Meislin Gallery, New York

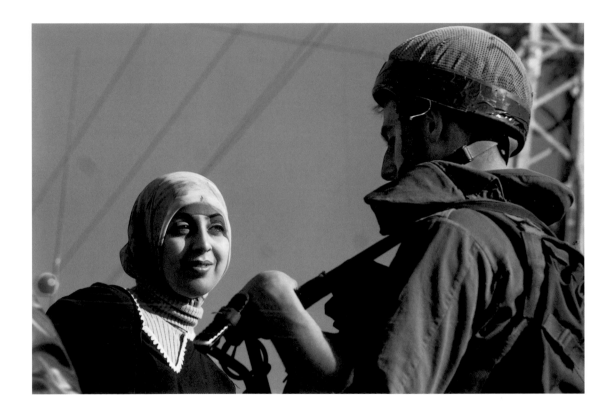

Plate 19
Pavel Wolberg (Israeli, b. Soviet Union 1966)
Qalqilya (Outskirts), 2002
Digital chromogenic print, 21½ × 31 in. (54.6 × 78.7 cm)
The Jewish Museum, New York, Purchase: Photography
Acquisitions Committee Fund, 2003–29

Plate 20
Miki Kratsman (Israeli, b. Argentina 1959)
Old Couple in Dahaisha Refugee Camp, Bethlehem, 2002
Chromogenic print, 39⅛ × 27½ in. (100 × 70 cm)
Chelouche Gallery, Tel Aviv

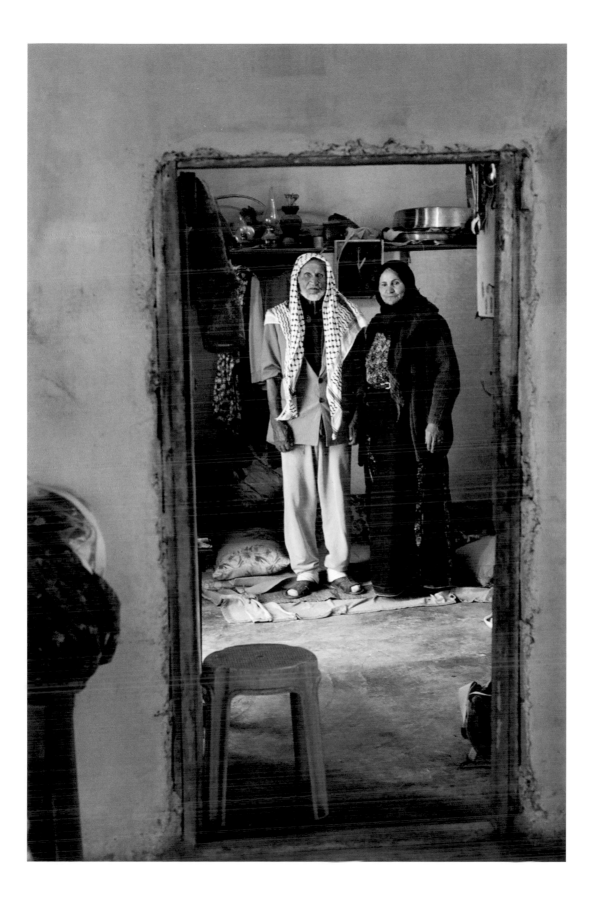

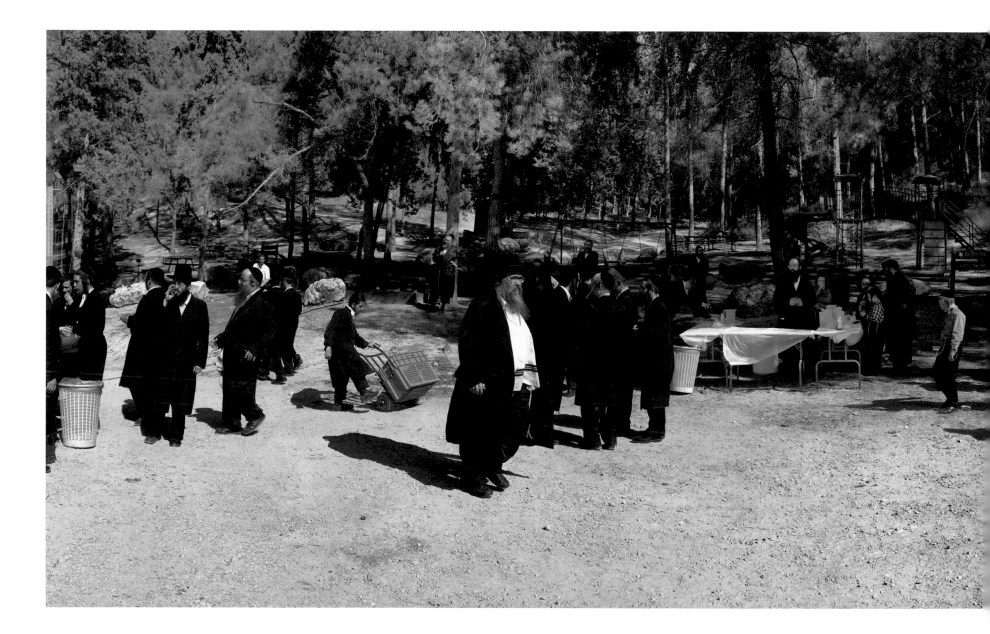

Plate 21
Barry Frydlender (Israeli, b. 1954)
The Blessing, 2005
Digital chromogenic print, 57⅜ × 162½ in. (145.8 × 412.8 cm)
Andrea Meislin Gallery, New York

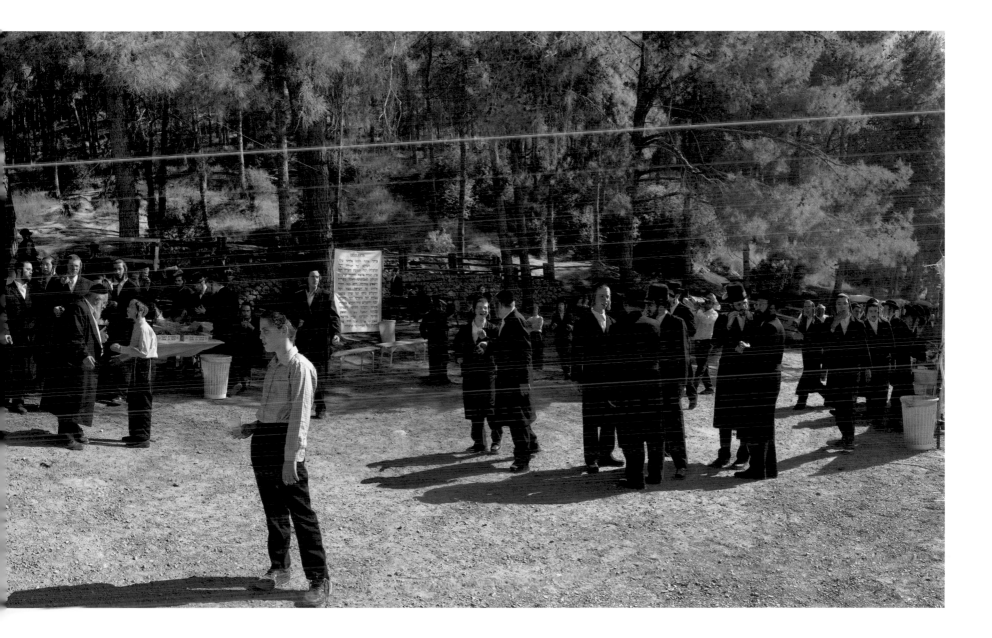

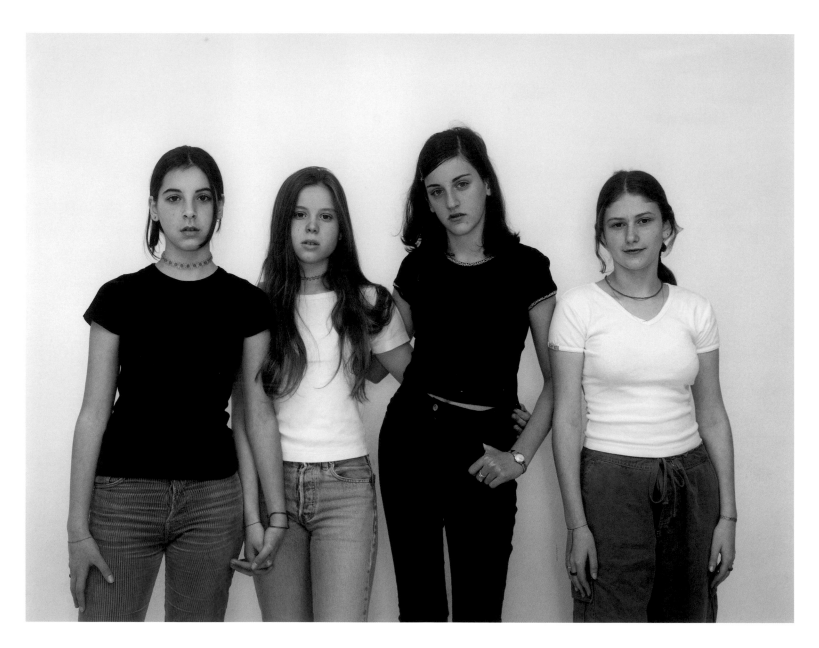

Plate 22
Rineke Dijkstra (Dutch, b. 1959)
Daniel, Adi, Shira, and Keren, Zeev Junior High School, Herzliya, Israel, April 12, 1999, 1999
Chromogenic print, 51¼ × 59⅞ in. (130 × 152 cm)
Marian Goodman Gallery, New York

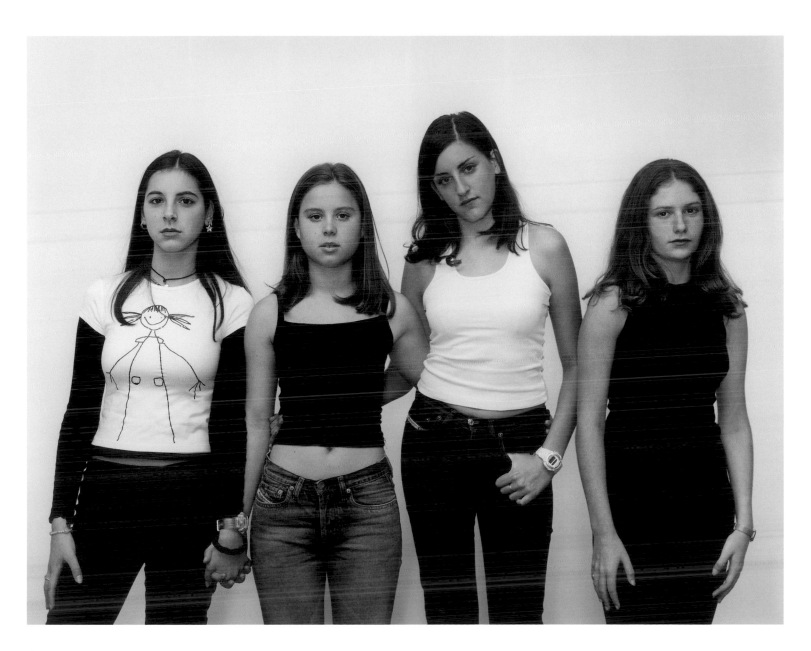

Plate 23
Rineke Dijkstra (Dutch, b. 1959)
Daniel, Adi, Shira, and Keren, Rishonim High School, Herzliya, Israel, December 17, 2000, 2000
Chromogenic print, 51¼ × 59⅞ in. (130 × 152 cm)
Marian Goodman Gallery, New York

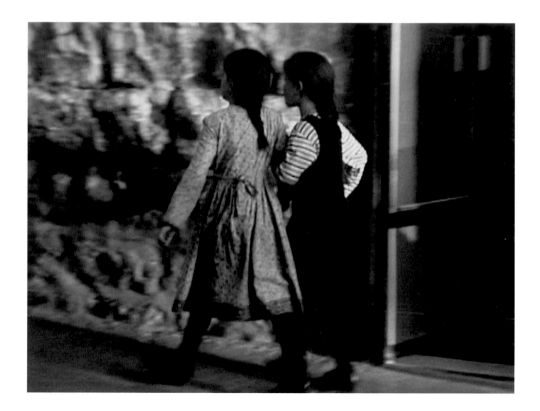

Plate 22
Leora Laor (Israeli, b. 1952)
Wanderland, 2002–4
Gelatin-silver prints; each 18 ×
24 in. (45.7 × 61 cm)
Andrea Meislin Gallery, New York

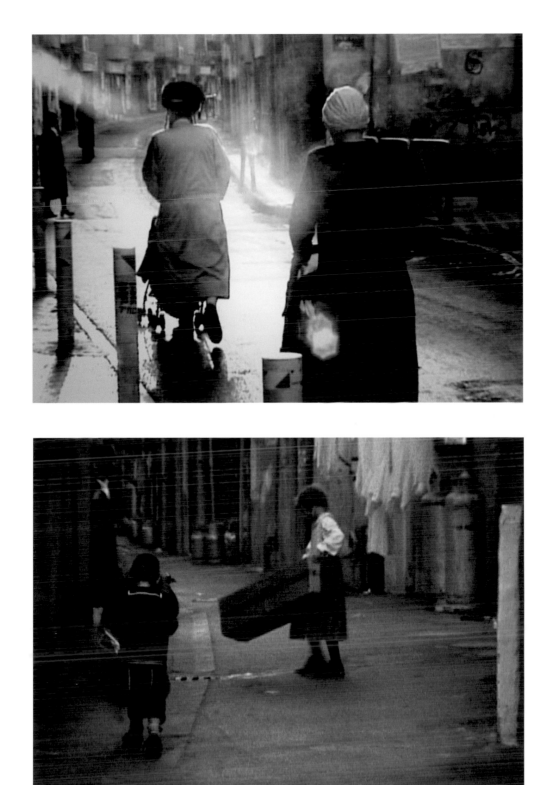

artist biographies

Boaz Arad

Born in 1956, Afula, Israel
Lives in Tel Aviv

EDUCATION
1995–96: Camera Obscura School of
Art, Tel Aviv
1978–82: Avni Institute for Fine Arts,
Tel Aviv

AWARDS AND PRIZES
2003: Prize to Encourage Creativity,
Ministry of Education, Culture, and
Sport, Israel

SELECTED GROUP EXHIBITIONS
2006
Equal and Less Equal, Museum on the
Seam, Jerusalem

Storytellers: University of Haifa Art
Gallery, Israel

Han Theater, Jerusalem

2005
Etched Voices, Yad Vashem, Jerusalem

Why Don't You Say It? Herzliya
Museum of Contermporary Art,
Israel

*1889 Beranau, Austria–1945 Berlin,
Germany,* Rosenfeld Gallery, Tel Aviv

Blanks, Center for Contemporary Art,
Tel Aviv

*November 4th 1995: Assassination in
Retrospect,* Bezalel Gallery, Tel Aviv

*Homemade, An Israeli Video Art Compi-
lation,* R. R. Cultural Center, Buenos
Aires

Israeli Contemporary Art, Kristine-
hamns Konstmuseum, Sweden

Homesick Home, Bern Zentrum fur
Kulturproduktion, Bern

2004
Alfabt—Contemporary Israeli Art,
Stockholmsmassan—Stockholm
International Fairs

Prizes of the Ministry of Education,
Haifa Museum, Israel

Untitled, Umm El-Fahim Art Gallery,
Israel

Israeli Video Art in Poland, Ujazdowski
Castle, Warsaw

Jewish Film Week Vienna, Jewish
Museum, Vienna

Local Time #7, Tel Aviv Cinematheque,
Israel

2003
*Wonderyears—New Reflections on Shoah
and Nazism in Israel,* Neue Gesell-
schaft für bildende Kunst, Berlin

Fiftieth International Art Exhibition,
Venice Biennale

Second Annual Detroit International
Video Festival

First Video Biennale, Tel Aviv

International Video Festival,
Manchuria

*Collins Selection of Documentary Films
by Contemporary Artists,* Barbican,
London

Art in General, New York

Foundation Modern Art Center,
Lisbon

2002
Mirroring Evil: Nazi Imagery/Recent Art,
The Jewish Museum, New York

Black Box, Argos, Brussels

Zoom In Zoom Out, Art in General,
New York

Yael Bartana

Born in 1970, Afula, Israel
Lives in Tel Aviv and Amsterdam

EDUCATION
2000–2001: Rijksakademie van
beeldende kunsten, Amsterdam
1999: M.F.A. studies, School of Visual
Arts, New York
1992–96: B.F.A., Bezalel Academy
of Art and Design, Jerusalem

AWARDS AND PRIZES
2005: Dorothea von Stetten-Kunst-
preis, Kunstmuseum Bonn, Germany
Prix de Rome, second award winner,
Rijksakademie, Amsterdam
2003: Anselm Kiefer Prize, Wolf
Foundation, Israel
1996: Samuel Prize for "Ant-Bulb,"
Bezalel Academy of Art and Design,
Jerusalem

SELECTED ONE-PERSON EXHIBITIONS
2007
Annet Gelink Gallery, Amsterdam

2006
Kunstverein Hamburg, Germany

Foksal Gallery, Warsaw

Stedelijk van Abbemuseum, Eind-
hoven, The Netherlands

2005

Sankt Gallen Kunstmuseum und Naturmuseum, St. Gallen, Switzerland

Annet Gelink Gallery, Amsterdam

2004

Sommer Contemporary Art, Tel Aviv

MIT List Visual Arts Center, Cambridge, Massachusetts

Prefix Institute of Contemporary Art, Toronto, Ontario

Büro Friedrich, Berlin

2003

P.S. 1 Contemporary Art Center, New York

Herzliya Museum of Contemporary Art, Israel

Annet Gelink Gallery, Amsterdam

Kerstin Engholm Galerie, Vienna

2002

Museum Beelden aan Zee, Scheveningen, The Netherlands

Variables X Y Z Digital Art Lab, Holon, Israel

2001

Caermersklooster—Provinciaal Centrum voor Kunst en Cultuur, Ghent, Belgium

SELECTED GROUP EXHIBITIONS

2006

Twenty-Fourth São Paulo Biennial, Brazil

The Art of Living: Contemporary Works from the Israel Museum, Contemporary Jewish Museum, San Francisco

2005

Ninth Istanbul Biennial, Istanbul

The New Hebrews: A Century of Art in Israel, Martin-Gropius-Bau, Berlin

Dorothea von Stetten Kunstpreis, Kunstmuseum Bonn, Germany

Irreducible, CCA Wattis Institue for Contemporary Arts, San Francisco

2004

Onufri Prize, National Gallery of Arts, Tirania, Albania

Time Zones: Recent Film and Video, Tate Modern, London

Time Depot, Petach Tikva Museum, Israel

Surfacing, Museum of Contemporary Art, Budapest

Wherever I Am, Modern Art Oxford, England

Liverpool Biennial, Festival for Contemporary Art, England

Point of Contact, Busan Biennale, South Korea

The Ten Commandments, Deutsches Hygiene Museum, Dresden

The Mediterraneans, MACRO Museum of Modern Art, Rome

2003

Wonderyears—New Reflections on Shoah and Nazism in Israel, Neue Gesellschaft für bildende Kunst, Berlin

Territories, KW Institute for Contemporary Art, Berlin

Fourth Gwangju Biennale, Gwangju, South Korea

2002

Rendez-Vous, Musée d'Art Contemporain de Lyon, France

Manifesta 4, European Biennial of Contemporary Art, Frankfurt am Main, Germany

Tele-Journeys, MIT List Visual Arts Center, Cambridge, Massachusetts

2001

Neue Welt, Frankfurter Kunstverein, Frankfurt am Main, Germany

2000

Greater New York, P.S. 1 Contemporary Art Center, New York

Rina Castelnuovo
Born in 1956, Tel Aviv
Lives in Jerusalem

EDUCATION

1974–77: Academy of Fine Arts, Rome

AWARDS AND PRIZES

Overseas Press Club Award
Associated Press Managing Editors Award
National Press Photographers' Association—Honorable Mention

SELECTED EXHIBITIONS

2005

Picture Israel, Andrea Meislin Gallery, New York

2003

Eyes on Jerusalem, Museo di Roma, Rome

2002

Conversations Through Photography, Watkins Gallery, American University, Washington, D.C.

Rineke Dijkstra
Born in 1959, Sittard, The Netherlands
Lives in Amsterdam

EDUCATION
1981–86: Gerrit Rietveld Academy, Amsterdam

AWARDS AND PRIZES
1998: Citibank Private Bank Photography Prize, Villa Arson, Nice, France
1994: Werner Mantz Award
1993: Art Encouragement Award, Amstelveen, The Netherlands
1991: Epica Award for Best European Advertising Photography
1990: Nomination for Young European Photographers
1987: Kodak Award Nederland

SELECTED ONE-PERSON EXHIBITIONS
2005
Fotomuseum Winterthur, Winterthur, Switzerland

Stedelijk Museum, Amsterdam

2004
Beach Portraits, ABN AMRO Plaza, LaSalle Bank, Chicago

2003
The Buzz Club and Mystery World, Marian Goodman Gallery, New York

2001
Art Institute of Chicago

Rineke Dijkstra, the Tiergarten and the French Foreign Legion, Frans Halsmuseum (De Hallen), Haarlem, The Netherlands

ICA Boston

Herzliya Museum of Art, Israel

2000
Marian Goodman Gallery, New York

SELECTED GROUP EXHIBITIONS
2006
Into Me/Out of Me, P.S. 1 Contemporary Art Center, New York

Clickdoubleclick, Haus der Kunst, Munich

2005
Girls' Night Out, Aspen Art Museum, Colorado

Belonging, Sharjah Biennial 7, Sharjah, United Arab Emirates

In Focus, North Carolina Museum of Art, Raleigh

2004
Lonely Planet, Contemporary Art Center/Gallery, ART TOWER MITO, Ibaraki, Japan

2003
Cruel and Tender: The Real in the Twentieth-Century Photograph, Tate Modern, London

The First ICP Triennial of Photography and Video, International Center of Photography, New York

Rineke Dijkstra, Paula Modershohn-Becker: Portraits, Kunstsammlungen Bottcherstrasse, Bremen, Germany

2002
Remix: Contemporary Art and Pop, Tate Liverpool, England

Moving Pictures, Solomon R. Guggenheim Museum, New York

De Grote Hoop (From the Low Countries), Fries Museum Leeuwarden, The Netherlands

Performing Bodies, Moderna Museet, Stockholm

Picturing Ourselves: Behind the Mask of Portraiture, Worcester Art Museum, Worcester, Massachussets

2001
At Sea, Tate Liverpool, England

Uniform—Order and Disorder, P.S. 1 Contemporary Art Center, New York

Platform of Humankind, Forty-Ninth International Art Exhibition, Venice Biennale

Kinderblicke—Kindheit und Moderne von Klee bis Boltanski, Stadt Bietigheim-Bissingen, Germany

2000
Children of the 20th Century, Von der Heydt Museum, Wuppertal, Germany

Conditions humaines, portraits intimes, Nederlands Foto Instituut, Rotterdam

Let's Entertain, Walker Art Center, Minneapolis

The Century of the Body: Photoworks 1900–2000, Musée de l'Elysée, Lausanne, Switzerland

Breathless! Photography and Time, Victoria & Albert Museum, London

Regarding Beauty: A View of the Late Twentieth Century, Hirshhorn Museum and Sculpture Garden, Smithsonian Institution, Washington, D.C.

Barry Frydlender
Born in 1954, Tel Aviv
Lives in Tel Aviv

EDUCATION
1976–80: Section of Film and Television, University of Tel Aviv

AWARDS AND PRIZES
2001: Constantiner Photography Award for an Israeli Artist, Tel Aviv Museum of Art, Israel
1985: Gérard Lévy Prize for a Young Photographer, Israel Museum, Jerusalem

SELECTED ONE-PERSON EXHIBITIONS
2006
New Work, Andrea Meislin Gallery, New York

2005
Rencontres de la Photographie, Thirty-Sixth Edition, Arles, France

2004
The Fourth Dimension, Andrea Meislin Gallery, New York

SELECTED GROUP EXHIBITIONS
2006
The Art of Living: Contemporary Photography and Video from the Israel Museum, Contemporary Jewish Museum, San Francisco

2005
New Work/New Acquisitions, Museum of Modern Art, New York

Chaim—Life: Israel through the Photographer's Lens, Laurie M. Tisch Gallery, Jewish Community Center (JCC), New York

2004
Current Visions, Andrea Meislin Gallery, New York

Water, Water Everywhere, Andrea Meislin Gallery, New York

2003
Here and Elsewhere, Passage de Retz, Paris

Youth Love, Riding Power Station, Tel Aviv

Young Israeli Art, Jacques and Eugenie O'Hana Collection, Tel Aviv Museum of Art, Israel

Public Space, Tel Aviv Museum of Art, Israel

2002
Chilufim: Exchange of Artists and Art, Israel Museum, Jerusalem, and Herzliya Museum of Art, Israel; Kunstmuseum Bonn, Kaiser Wilhelm Museum, Krefeld, and Museum am Ostwall, Germany

Explora Digital Art, Kalisher Gallery, Tel Aviv

2001
Tel Aviv-Berlin: New Media Experience, NOVALOG, Berlin

Ori Gersht
Born in 1967, Tel Aviv
Lives in London

EDUCATION
1993–95: M.A. in Photography, Royal College of Art, London
1982–92: B.A. (Honors) in Photography, Film, and Video, University of Westminster, London

AWARDS AND PRIZES
2004: First Prize, Onfuri International, Tirana, Albania
2003: Commissioned by the Museum of Nottingham Castle to produce site-specific work for the *Drawing with Light* exhibition
BBC White City Public Art Strategy Photographic Commission
2000: Constantiner Photography Award for an Israeli artist, Tel Aviv Museum of Art, Israel
1993: British Transport Competition, Mall Gallery, London
1990: South Bank: Annual Show, Royal Festival Hall, London

SELECTED ONE-PERSON EXHIBITIONS
2006
Photographers' Gallery, London

2005
CRG Gallery, New York

2004
Andrew Mummery Gallery, London

Noga Gallery of Contemporary Art, Tel Aviv

History in the Making, Photo España, Madrid

Angles Gallery, Santa Monica, California

CRG Gallery, New York

Armory Show, New York

2003
CRG Gallery, New York

2002
Tel Aviv Museum of Art, Israel

Andrew Mummery Gallery, London

Tate Britain, London

Angles Gallery, Santa Monica, California

2001
Andrew Mummery Gallery, London

Liste 01, Young Art Fair in Basel, with Andrew Mummery Gallery, Switzerland

Noga Gallery of Contemporary Art, Tel Aviv

Belfast Exposed, Belfast

Martin Kudlek Gallery, Cologne

Refusalon, San Francisco

2000
Gardner Art Centre, Brighton, England

Chisenhale Gallery, London

Amit Goren

Born in 1957, Tel Aviv
Lives in Tel Aviv

EDUCATION
1981–83: B.A., New York University,
Department of Film and Television

AWARDS AND PRIZES
1998: Wolgin Award for Best Documentary—Jerusalem International
Film Festival
1996: Special Jury Commendation,
FIPA Biarritz
1995: Wolgin Award for Best Documentary—Jerusalem International
Film Festival
Foundation for Cinema and Television Best Director Award
Best Video Documentary, International Documentary Festival
Amsterdam
Prix Futura Berlin
1994: First Prize for Documentary—
Grand Reportage, FIPA Nice
Gadi Danzig Cinematography Prize
for Documentary
San Francisco International Film
Festival
1993: Ministry of Education Prize for
Excellence in Cinema, Israel

1992: Wolgin Award for Best Documentary
Israel Academy of Film and Television Award for Best Documentary
1991: Prix Futura Berlin—Best Fiction
Film
1990: Best Fiction Film, Chicago
International Film Festival
1989: Silver Mikeldi Prize for Fiction
Film, Bilbao International Film
Festival
Israeli Film Institute Prize for Cinematography
Israeli Film Institute Prize for Editing

SELECTED EXHIBITIONS
2006
Interrupted Histories, Moderne Galerija, Ljubljana, Slovenia

Cinema from the Promised Lands, Haus
der Kultur der Welt, Berlin

2004
*Minority Report—Challenging Intolerance
in Contemporary Denmark*, Aarhus Festival of Contemporary Art, Aarhus,
Denmark

Hilchot Shchenim, Israeli Centre for
Digital Art, Holon

Making Differences, Historiska
Museum, Stockholm

Mediterraneans, MACRO Museum of
Modern Art, Rome

2003
International Documentary Festival,
Amsterdam

Jerusalem International Film Festival

Sundance at MOMA: Illuminated Voices,
Museum of Modern Art Films,
Gramercy Theatre, New York

Delays and Revolutions, Fiftieth International Art Exhibition, Venice Biennale

Diaries, Chelouche Gallery, Tel Aviv

2002
Makom Project, Israel Museum,
Jerusalem (traveled to Tel Aviv)

2000
Manifesta 3, European Biennial
for Contemporary Art, Ljubljana,
Slovenia

Angelos Novos, Museum of Contemporary Art, Siena, Italy

Angel of History, Palazzo Delle
Papesse Center for Contemporary
Art, Siena, Italy

Exit, Chisenhale Gallery, London

Cinema Memoire Familiale, Musée d'art
et d'histoire du Judaïsme, Paris

Michal Heiman

Born in 1954, Tel Aviv
Lives in Tel Aviv

EDUCATION
1982–84: Painting and sculpture
studies at the Art Teachers Training
College, Ramat Hasharon, Israel
1977–79: Photography studies,
Hadassah College, Jerusalem

AWARDS AND PRIZES
2004: Kabilio Prize for Photography,
Israel Museum, Jerusalem
2003: Ministry of Education and
Culture Prize for Plastic Arts, Israel
1996: Ministry of Education and Culture Prize for Plastic Arts, Israel

SELECTED ONE-PERSON EXHIBITIONS
2005
I Was There, Andrea Meislin Gallery,
New York

Rencontres de la Photographie Arles,
France

2004
What's on Your Mind? M. H. T. No. 3,
Acre Fringe Festival for Theatre

SELECTED GROUP EXHIBITIONS

2006

The Art of Living: Contemporary Photography and Video from the Israel Museum, Contemporary Jewish Museum, San Francisco

Mixed Emotions, Haifa Museum of Art, Israel

2004

How to Explain Pictures to a Dead Hare, Polak Gallery, Tel Aviv

Sun-Moon—Michal Heiman & Rashid Mashrawi, Vierje Academy of Art, The Hague, The Netherlands

Terrorvision, Exit Art, New York

Art and War, Goethe-Institute, Tel Aviv

Israeli Photographers Photographing Themselves Photographing, Genia Schreiber University Art Gallery, Tel Aviv University

2002

Home Is Where We Start From, Factory "Comme-il Faut," Tel Aviv

2001

Israeli Art in Japan, Moma-Saitama Museum, Tokyo

Noel Jabbour

Born in 1970, Nazareth
Lives in Berlin

EDUCATION

1998–2000: Postgraduate studies at Bezalel Academy of Art and Design, Jerusalem (Young Artist's Program)
1992–95: Hadassah College, Jerusalem (Department of Photography/Diploma)

AWARDS AND PRIZES

2005: Musée Nicéphore Niépce (Artist-in-Residence)
2002–03: Ateliers des Artistes de la Ville de Marseille (Artist-in-Residence)
2000: Young Artist of the Year, A. M. Qattan Foundation, Ramallah
1999–2000: America-Israel Culture Foundation Scholarship
1999: Artist-in-Residence, Epinay-sur-Seine, France
1994: First Prize for Documentary Photography, Hadassah College, Jerusalem

SELECTED ONE-PERSON EXHIBITIONS

2005

Museum of Art, Ein Harod, Israel

2004

The Living Road, Tel Aviv Artist's Studios, Tel Aviv

The Maria Magdalene Series, f.a. projects, London

SELECTED GROUP EXHIBITIONS

2006

The Art of Living: Contemporary Photography and Video from The Israel Museum, Contemporary Jewish Museum, San Francisco

FOTOFEST 2006 *"The Earth,"* Eleventh International Biennial of Photography, Houston

Thy Brothers' Keeper, Flint Institute of Arts, Flint, Michigan

2005

Chaim—Life: Israel Through the Photographer's Lens, Laurie M. Tisch Gallery, Jewish Community Center (JCC), New York

2004

Nazar/Images from the Arab World, Noorderlicht Photofestival, Fries Museum, Leeuwarden, The Netherlands (traveled in Europe and the U.S.)

Current Visions: Inside Israel, artis, New York

Utopia, Beit Hagefen, the Arab-Jewish Center, Haifa

2002

Corpus Christi, Patrimoine Photographique, Hôtel de Sully, Paris

2001–02

In weiter Ferne so nah—Neue Palstinensische Kunst, Ifa-Galerie Bonn (traveled in Germany)

2001

Centro Cultural Recoleta, Buenos Aires

Miki Kratsman

Born in 1959, Argentina
Immigrated to Israel in 1971
Lives in Tel Aviv

EDUCATION

1982–85: College of Photography, Kiriyat Ono, Israel

AWARDS AND PRIZES

2001: Ministry of Education and Culture Prize, Israel
British Multi Exposure Grant
1997: Enrique Calvin Israel Museum Prize for Photography

SELECTED ONE-PERSON EXHIBTIONS

2003

Israel Museum, Jerusalem

2002

Nelly Aman Gallery, Tel Aviv

2001

Nelly Aman Gallery, Tel Aviv

SELECTED GROUP EXHIBITION

2007

Twenty-Seventh São Paulo Biennial, Brazil

2006

De Hallen, Brugge, Belgium

Equal and Less Equal, Museum on the Seam, Jerusalem

2005
Menier Gallery, London

Lieu Commun, Paris

Martin-Gropius-Bau Museum, Berlin

2004
Umm El-Fahim Gallery, Israel

2003
Fiftieth International Art Exhibition, Venice Biennale

2002
Tel Aviv Museum of Art, Israel

2001
Maison Robert Doisneau, Paris

2000
Herzliya Museum of Art, Israel

Palazzo delle Papesse Center for Contemporary Art, Siena, Italy

Leora Laor
Born in 1952, Jerusalem
Lives in Jerusalem

EDUCATION
1996: Graphic Design Department, Ministry of Labour, Israel
1981: Photography Department, New School, New York
1979–80: Photography Department, School of Visual Arts, New York
1973–77: B.F.A., Film and Television Department, Tel Aviv University

AWARDS AND PRIZES
2005: Constantiner Photography Award for an Israeli Artist, Tel Aviv Museum of Art

SELECTED ONE-PERSON EXHIBITIONS
2006
New Work, Andrea Meislin Gallery, New York

Leora Laor: Images of Light, Ellen Curlee Gallery, St. Louis

Wanderland: Works by Leora Laor, Laurie M. Tisch Gallery, Jewish Community Center (JCC), New York

2005
Leora Laor: Image of Light, Stephen Daiter Gallery, Chicago

Dvir Gallery, Tel Aviv

2004
ParisPhoto, Le Carrousel du Louvre, Paris

Wanderland, Andrea Meislin Gallery, New York

SELECTED GROUP EXHIBITIONS
2005
Recent Acquisitions/Nieuwe Aanwinsten, Museum of Photography, The Hague, The Netherlands

The Constantiner Photography Award for an Israeli Artist 2005: Pavel Wolberg, Leora Laor, Igael Shemtov, Tel Aviv Musuem of Art, Israel

Lights, Israel Museum, Jerusalem

Chaim—Life: Israel Through the Photographer's Lens, Laurie M. Tisch Gallery, Jewish Community Center (JCC), New York

Fotografia Israellana Contemporana, Hendrik C. Anderson, Rome

Luca Pagliari and Others, After Hopper, Bonni Benrubi Gallery, New York

2004
Étude pour un Premier Amour, Dvir Gallery, Tel Aviv

Water Water Everywhere, Andrea Meislin Gallery, New York

Current Visions: Inside Israel, Andrea Meislin Gallery, New York

2000
Saying Hello, Peace Gallery, Givat-Haviva Arts Center, Israel

Gillian Laub
Born in 1975, Port Chester, New York
Lives in New York City

EDUCATION
1998: International Center for Photography, New York
1997: B.A., Comparative Literature, University of Wisconsin, Madison
American University of Paris

AWARDS AND PRIZES
2005: Nikon Storytellers Award, Photo District News Photo Annual 2005, New York
2003: World Press Photo; Joop Swart Master Class Award participant

SELECTED EXHIBITIONS
2006
Learning from a Vast River of Suffering: A Global Human Rights Epidemic, Human Rights Gallery, William Benton Museum of Art, University of Connecticut, Storrs

2005
New Art, New York: Reflections of the Human Condition, Trierenberg AG Gallery, Traun, Austria

2004
Shifting the Political, Center for Photography at Woodstock, New York

Common Ground, Bonni Benrubi Gallery, New York

Water, Water, Everywhere, Andrea Meislin Gallery, New York

Terrorvision, Exit Art, New York

Beyond Compare: Women Photographers on Beauty, Presented by Dove, Toronto, Ontario (traveled in Canada)

2003
By the Sea, Yossi Milo Gallery, New York

Flash: Swimsuits & Sports, Jackson Fine Art, Atlanta

Enough, FOAM Photography Museum, Amsterdam

CMYK: Contemporary Color, Bonni Benrubi Gallery, New York

2002
Advance Notice, International Center for Photography, New York

Sexuality and Voyeurism, Wayne State University, Detroit

At Play, SoHo Triad Fine Arts, New York

2001
Summer Salon IV, Bonni Benrubi Gallery, New York

Identity in Relationships, Makor Gallery, New York

Family, Woodstock Center for Photography, Woodstock, New York

Paris Photo International, Le Carrousel du Louvre, Paris

2000
Air Conditioned, Bonni Benrubi Gallery, New York

Yaron Leshem
Born in 1972, Jerusalem
Lives in New York

EDUCATION
1999–2004: B.F.A. in photography, Bezalel Academy of Art and Design, Jerusalem

AWARDS AND PRIZES
2004: Prize for Excellence from Bezalel Academy of Art and Design, Jerusalem

SELECTED GROUP EXHIBITIONS
2006
"Mini Israel": 70 Models, 45 Artists, One Space, Israel Museum, Jerusalem

International and National Projects, P.S. 1 Contemporary Art Center, New York

Biennale Cuvee, O. K. Centrum fur Gegenwartskuns, Linz, Austria

2005
Tokyo Wonder Site, Japan

2004
Video Zone, Herzliya Museum of Contemporary Art, Israel

Tel Chai Museum for Photography, Israel

Bloomfield Science Museum, Jerusalem

Motti Mizrachi
Born in 1946, Tel Aviv
Lives in Tel Aviv

EDUCATION
1969–74: Bezalel Academy of Art and Design, Jerusalem

AWARDS AND PRIZES
2002: Ministry of Science, Culture, and Sport Prize, Israel
2001: Dan Sandel and Sandel Family Foundation Sculpture Award, Tel Aviv Museum of Art, Israel
1987: Israel Discount Bank prize for a Young Israeli Artist, Israel Museum, Jerusalem
America-Israel Culture Foundation Prize, Jerusalem
Sandberg Prize for an Israeli Artist, Israel Museum, Jerusalem
1976: Beatrice S. Colliner Prize for a Young Israeli Artist, Israel Museum, Jerusalem

SELECTED ONE-PERSON EXHIBITIONS
2004
Passion, Chelouche Gallery, Tel Aviv

Wailing, Dvir Gallery, Tel Aviv

Compassion, Midrasha Gallery, Tel Aviv

2002
Chelouche Gallery, Tel Aviv

City Hall Gallery, Yavne, Israel

2001
Braunstein/Quay Gallery, San Francisco

Chelouche Gallery, Tel Aviv

2000
Haifa Museum of Art, Israel

SELECTED GROUP EXHIBITIONS
2004
Love Is in the Air, Time for Art Gallery, Tel Aviv

The Puppet Show, Time for Art Gallery, Tel Aviv

2001
Surface Talk, Chelouche Gallery, Tel Aviv

Art Basel 34, Basel, Switzerland

Mifkad, Chelouche Gallery, Tel Aviv

Valencia Biennial, Spain

Thou Shall Make . . . Resurgence of Judaism in Israeli Art, Time for Art Gallery, Tel Aviv

2000
The Collection, Museum Moderner Kunst, Vienna

The Boundaries of Sculpture, Avraham Baron Gallery, Ben Gurion University, Beer-Sheva, Israel

The Water Division, Acco Festival, Israel

Concept es de l'espai, Fundació Joan Miró, Barcelona

Alien Seedling, Janco DADA Museum, Ein-Hod, Israel

Orit Raff

Born in 1970, Jerusalem
Lives in New York and Tel Aviv

EDUCATION

2002: M.F.A., Milton Avery Graduate
School of the Arts, Bard College, New
York
1999–2000: International Studio
Program, New York
Independent Study Program, Whit-
ney Museum of American Art, New
York
1996: B.F.A. (cum laude), School of
Visual Arts, New York
1992–94: Bezalel Academy of Art
and Design, Jerusalem

AWARDS AND PRIZES

2004: MIFAL HAPAIS—Israel National
Lottery Council for the Arts Grant
2002: Milton and Sally Avery Scholar-
ship
2001: Peter S. Reed Foundation Grant
in the field of the visual arts
1999: Special Award for Originality
and Innovation, Croatia Biennial,
Dubrovnik
1997: America-Israel Culture Founda-
tion Fellowship

1995: Award of Excellence, School of
Visual Arts Mentor Program, New
York
1994: Student Exchange Scholarship,
Bezalel Academy of Art and Design,
Jerusalem
1992: Special Presidential Grant for
Excellence, Bezalel Academy of Art
and Design, Jerusalem

SELECTED ONE-PERSON EXHIBITIONS

2005
Julie Saul Gallery, New York

Noga Gallery of Contemporary Art,
Tel Aviv

2004
Julie Saul Gallery, New York

2003
Cutting Edge Project at ARCO '03,
Madrid

2002
Dynamic Equilibrium, Site Santa Fe,
New Mexico

Paula Boettcher Gallery, Berlin

Museum of Israeli Art, Ramat Gan,
Israel

The Pot Calling the Kettle Black, Julie
Saul Gallery, New York

Keep In a Cool and Dry Place, Bineth
Gallery, Tel Aviv

Howard Yezerski Gallery, Boston

2001
Todd Hosfelt Gallery, San Francisco

Borowsky Gallery, Philadelphia

2000
Thirty Times the Length of My Breath,
Todd Hosfelt Gallery, San Francisco

Mobius Strip, Baumgartner Gallery,
New York

Innen Zeichnung, LISTE 2000 Young Art
Fair Basel with the Paula Bottcher
Gallery, Berlin

Approaching Saturation, Houston Cen-
ter for Photography

Inside Drawing, Julie Saul Gallery,
New York

Guy Raz

Born in 1964, Kibbutz Geva, Israel
Lives in Tel Aviv

EDUCATION:

2000–2004: M.A. in art, Hebrew
University Jerusalem
1997–98: B.F.A. in art, graduate stud-
ies, Bezalel Academy of Art and
Design, Jerusalem
1990–93: Camera Obscura School
of Art, Tel Aviv

AWARDS AND PRIZES

2000: Prize for Adult Israeli Artist,
Ministry of Science and Arts, Israel
1995: Prize for Young Israeli Artist,
Ministry of Science and Arts, Israel

SELECTED ONE-PERSON EXHIBITIONS

2005
Mizmor (The warrior muse), Nelly
Aman Gallery, Tel Aviv

2002
Nelly Aman Gallery, Tel Aviv

2000
Nelly Aman Gallery, Tel Aviv

SELECTED GROUP EXHIBITIONS

2005
Biennale of Photography, Guangzhou,
China

2004

Current Visions: Inside Israel, Andrea Meislin Gallery, New York

A Point of View, Tel Aviv Museum of Art, Israel

Water Water Everywhere, Andrea Meislin Gallery, New York

Mediterranean: a place between reality & utopia, Photographers' Gallery, London

2003

The Promise, The Land, O. K. Centrum fur Gegenwartskunst, Linz, Austria

2000

Photography in Israel: A Changing View, Fotofest 2000, Margolis Gallery, Houston

Seventh Havana Biennale, Cuba

Re-Thinking, ifa-Galerie Bonn (traveled in Germany)

Igael Shemtov
Born in 1952, Naharia, Israel
Lives in Binyamina, Israel

EDUCATION
1983–85: M.F.A., Pratt Institute, New York
1979–81: Art Teaching Training College, Ramat Hasharon, Israel
1977–79: Bezalel Academy of Art and Design, Jerusalem
1975–78: Neri Bloomfield College of Design, Haifa

AWARDS AND PRIZES
2005: Constantiner Photography Award for an Israeli Artist, Tel Aviv Museum of Art, Israel
2003: Ministry of Education and Culture Award, Israel
Ministry of Education, Culture, and Sport, Israel
1999: George and Janet Jaffin Prize, America-Israel Culture Foundation
1991: Ministry of Education Award, Council for Culture and Arts
1981: Enrique Kavlin Prize, Israel Museum, Jerusalem
America-Israel Culture Foundation
1980: America-Israel Culture Foundation

1979: Young Artist Prize, Ministry of Education and Culture
America-Israel Culture Foundation
1978: Halperin Prize, Bezalel Academy of Art and Design, Jerusalem

SELECTED ONE-PERSON EXHIBITIONS
2004
Low Landscape Low Reality, Loushy Art & Editions, Tel Aviv

SELECTED GROUP EXHIBITIONS
2006
The Art of Living: Contemporary Photography and Video from The Israel Museum
Contemporary Jewish Museum, San Francisco

2005
The Constantiner Photography Award for an Israeli Artist 2005: Pavel Wolberg, Leora Laor, Igael Shemtov, Tel Aviv Museum of Art, Israel

Camera Sacra, Israel Museum, Jerusalem

2004
Current Visions: Inside Israel, artis, New York

2001
A Week Ago, on Monday, Yesterday, Ami Steinitz Gallery, Tel Aviv

Starr Gallery, Newton, Massachusetts

2000
Between Mountain and Sea, Municipal Museum, Haifa

Time Frame, A Century of Photography in the Land of Israel, Israel Museum, Jerusalem

Wolfgang Tillmans
Born in 1968, Remscheid, Germany
Lives in London

EDUCATION
1990–92: Bournemouth and Poole College of Art and Design, England

AWARDS AND PRIZES
2000: Turner Prize, Tate
1995: Viva Prize from the Kulturkreis der Deutschen Wirtschaft Böttcherstrasse Prize, Bremen

SELECTED ONE-PERSON EXHIBITIONS
2006
Freedom from the Known, P.S. 1 Contemporary Art Center, New York

Helsinki Festival, Finland
Kestner-Gesellschaft, Hannover, Germany

Museum of Contemporary Art, Chicago

2005
Galeria Juana de Aizpuru, Madrid

Markt, Galerie Meerrettich, Berlin

Press to Exit Project Space, Skopje, Macedonia

2004

Freischwimmer, Tokyo Opera City Gallery, Tokyo

Neugerriemschneider, Berlin

Regen Projects, Los Angeles

Wako Works of Art, Tokyo

2003

Andrea Rosen Gallery, New York

Landscapes, Frans Hals Museum, Haarlem, The Netherlands

If One Thing Matters, Everything Matters, Tate Britain, London

Louisiana Museum for Moderne Kunst, Humlebæk, Denmark

Galerie Daniel Buchholz, Cologne, Germany

2002

Wolfgang Tillmans: Still life, Busch Reisinger Museum, Harvard University Art Museums, Cambridge, Massachusetts

Vue d'en Haut, Palais de Tokyo, Paris

Veduta dall'alto, Castello di Rivoli—Museo d'Arte Contemporanea, Turin, Italy

Partnerschaften II, Neue Gesellschaft für Bildende Kunst, Berlin (with Jochen Klein)

Sommer Contemporary Art, Tel Aviv

2001

Deichtorhallen, Hamburg, Germany

Science Fiction / Hier und Jetzt Zufrieden sein AC: Isa Genzken, Wolfgang Tillmans, Museum Ludwig, Cologne, Germany

Super Collider, Galerie Daniel Buchholz, Cologne, Germany

2000

Apocalypse, Beauty and Horror in Contemporary Art, Royal Academy of Arts, London

The British Art Show 5, Hayward Gallery, London

Mark Wallinger
Born in 1959, Essex, England
Lives in London

EDUCATION
1983–85: M.A., Goldsmiths College, London
1978–81: Chelsea School of Art, London
1977–78: Loughton College, England

AWARDS AND PRIZES
2003: Honorary doctorate, University of Central England, Birmingham
2002: Honorary fellowship, London Institute
2001: DAAD Berlin Artists Program
1998: Henry Moore Fellowship, British School, Rome
1995: Turner Prize, Tate Gallery, London

SELECTED ONE-PERSON EXHIBITIONS
2006
Anthony Reynolds Gallery, London

Threshold to the Kingdom, Convent of Saint Agnes of Bohemia, National Gallery, Prague

2005
Museo de Arte Carillo Gil, Mexico City

W—E, Galerie Krinzinger, Vienna

2004
Sleeper, Neue Nationalgalerie, Berlin

Presence 4: Mark Wallinger, Speed Art Museum, Louisville, Kentucky

Anthony Reynolds Gallery, London

2003
Christmas Tree, Tate Britain, London

The Sleep of Reason, The Wolfsonian, Florida

Via Dolorosa, Städtische Galerie im Lenbachhaus, Munich

Spacetime, Carlier Gebauer, Berlin

2002
Cave, Millennium Forum, Derry, Ireland

Mark Wallinger—Seeing Things, Minoriten-Galerien im Priesterseminar, Graz, Austria

Promised Land, Tensta Konsthall, Spanga, Sweden

2001
No Man's Land, Whitechapel Art Gallery, London

Forty-Ninth International Art Exhibition, Venice Biennale

Time and Relative Dimensions in Space, University Museum of Natural History, Oxford, England

2000
Credo, Tate Liverpool, England

Ecce Homo, Vienna Secession, Vienna

Galeria Laura Pecci, Milan

Threshold to the Kingdom, British School, Rome

Wim Wenders

Born in 1945, Düsseldorf, Germany
Lives in Los Angeles and Berlin

EDUCATION

1967–70: Hochschule für Fernsehen und Film (Academy of Film and Television), Munich
1963–65: Studied medicine and philosophy in Munich, Freiburg, and Düsseldorf

AWARDS, HONORS, AND PRIZES

2006: Miami International Film Festival Career Achievement Tribute
2000: *The Million Dollar Hotel*
Berlin Film Festival: Silver Bear Jury Prize
1999: *Buena Vista Social Club*
European Film Award: Best Documentary
New York Film Critics Circle: Best Documentary
Los Angeles Film Critics Association: Best Documentary
Edinburgh International Film Festival: Standard Life Audience Award
National Board of Review: Best Documentary
Academy Award Nominee, Best Documentary

1997: *The End of Violence*
German Film Prize: Gold Director's Prize
1995: Honorary doctorate in divinity from the theological faculty of Fribourg University, Switzerland
1993: *Far Away, So Close!*
Cannes Film Festival: Grand Jury Prize
Honorary professor at the HFF (Academy of Film and Television), Munich
1991: Friedrich Wilhelm Murnau Award, Bielefeld
1989: Honorary doctorate from the Sorbonne University, Paris
1987: *Wings of Desire*
Cannes Film Festival: Best Director
European Film Prize: Best Director
Los Angeles Film Critics Association Award: Best Foreign-Language Film, Best Cinematography
New York Film Critics Circle: Best Photography
1984: *Paris, Texas*
Cannes Film Festival: Palme d'Or
British Academy Awards: Best Director
1982: *The State of Things*
Venice Film Festival: Golden Lion, Fipresci Prize
1977: *The American Friend*
German Film Prize, gold: Best Director, Best Editing
German Film Prize, silver: Production
1976: *Kings of the Road*
Chicago International Film Festival: Golden Hugo
1975: *Wrong Move*
German Film Prize: Best Director, Best Screenplay, Best Cinematography

1971: *The Goalkeeper's Fear of Penalty*
Venice Film Festival: Prize of the Film Critics

SELECTED ONE-PERSON EXHIBITIONS

2006
Journey to Onomichi—Photos by Wim and Donata Wenders, Omotesando Hills, Tokyo

Salon of the Museum of Contemporary Art, Belgrade, Serbia

Dark Places, Santa Monica Museum of Art, California

2005
The Forest: Politics, Poetics, and Practice, Nasher Museum of Art at Duke University, Durham, North Carolina

2004–05
ARoS Aarhus Kunstmuseum, Aarhus, Denmark

2004
James Cohan Gallery, New York

Galleria Marabini, Bologna, Italy

2003
James Cohan Gallery, New York

Galerie Judin Belot, Zurich

2000–2004
Pictures from the Surface of the Earth, Hamburger Bahnhof, Berlin

2000
Buena Vista Social Club, Rose Gallery, Santa Monica, California

Pavel Wolberg

Born in 1966, Leningrad, U.S.S.R.
Immigrated to Israel in 1973
Lives in Tel Aviv

EDUCATION

1990–94 Photography studies, Camera Obscura School of Art, Tel Aviv

AWARDS AND PRIZES

2005: Constantiner Photography Award for an Israeli Artist, Tel Aviv Museum of Art, Israel
2003: America-Israel Culture Foundation Prize
2002: Ministry of Science, Culture, and Sport Prize
1997: Gérard Lévy Prize for a Young Photographer, Israel Museum, Jerusalem
1994–95: America-Israel Culture Foundation Scholarship

SELECTED ONE-PERSON EXHIBITIONS

2002
Point Blank [Israel]: Pavel Wolberg, Photographs of the Recent Time, Tel Aviv Museum of Art, Israel

1997
Dvir Gallery, Tel Aviv

1995
Herzliya Museum of Art, Israel

SELECTED GROUP EXHIBITIONS

2006
Mixed Emotions, Haifa Museum of Art, Israel

ICONICA, Museo Patio Herreriano, Valladolid, Spain

Musée d'Art Moderne Grand-Duc Jean, Luxembourg

2005
The Constantiner Photography Award for an Israeli Artist 2005: Pavel Wolberg, Leora Laor, Igael Shemtov, Tel Aviv Museum of Art, Israel

Chaim—Life, Israel Through the Photographers' Lens, Laurie M. Tisch Gallery, Jewish Community Center (JCC), New York

The New Hebrews—A Century of Art in Israel, Martin-Gropius-Bau, Berlin

2004
A Point of View, Tel Aviv Museum of Art, Israel

Terrorvision, Exit Art, New York

Alphabet—Israeli Contemporary Art, Stockholm Art Fair, Sweden

Etude pour un Premier Amour (no. 3), Dvir Gallery, Tel Aviv

2003
America-Israel Culture Foundation Prize for 2003, Ramat Gan Museum of Israeli Art, Israel

2002
Nashakia, Goch Museum, Germany

Corpus Christi, Patrimoine Photographique, Hôtel de Sully, Paris

Chilufim: Exchange of Artists and Art, Israel Museum, Jerusalem, and Herzliya Museum of Art, Israel; Kunstmuseum Bonn, Kaiser Wilhelm Museum, Krefeld, and Museum am Ostwall, Germany

2001
Dvir Gallery, Tel Aviv

Sharon Ya'ari
Born in 1966, Holon, Israel
Lives in Tel Aviv

EDUCATION
1998–2002: M. Phil, Derby University, England
1990–94: Bezalel Academy of Art and Design, Jerusalem
1989–90: Studied philosophy and literature, Tel Aviv University

AWARDS AND PRIZES
2000: Minister of Culture Prize, Israel
1999: Gérard Lévy Prize for a Young Photographer, Israel Museum, Jerusalem
1997: Young Artist Prize, Ministry of Education and Culture, Israel
1996: America-Israel Culture Foundation

SELECTED ONE-PERSON EXHIBITIONS
2006
Hope for Long Distance Photography, Tel Aviv Museum of Art, Israel

2003
Sharon Ya'ari, Dust, Lombard-Freid Fine Arts, New York

2002
Lisson Gallery, London

Sommer Contemporary Art, Tel Aviv

Project Room Arco, Madrid

Drexel University Art Gallery, Philadelphia

2001
Last Year, Lombard-Freid Fine Arts, New York

2000
Sommer Contemporary Art, Tel Aviv

SELECTED GROUP EXHIBITIONS
2005
The New Hebrews —A Century of Art in Israel, Martin-Gropius-Bau, Berlin

Such Stuff as Dream Are Made On, Chelsea Art Museum, New York

2004
A Point of View, Tel Aviv Museum of Art, Israel

Behind Faces, Galerie Martin Janda, Vienna

Monart Museum, Ashdod, Israel

2003
Fabula, National Museum of Photography, Film, and Television, Bradford, England

Space and Subjectivity, Prague Biennale

Sommer Contemporary Art, Tel Aviv

The First ICP Triennial of Photography and Video, International Center of Photography, New York

2002
Phil Collins, Daniela Rossell, Sharon Ya'ari, Anthony Wilkinson Gallery, London

Multitude, Artists Space, New York

Fragile Line, Umm El-Fahim Gallery, Israel

2001
Aspiration, RIFFE Gallery, Columbus, Ohio

2000
Contemporary Landscape, MOCA, Roskilde, Denmark

Surveying the Landscape, Lombard-Freid Gallery, New York

Photography in Israel—A Changing View Fotofest 2000, Margolis Gallery, Houston

Catherine Yass

Born in 1963, London
Lives in London

EDUCATION
1988–90: M.A. in fine art, Goldsmiths College, London
1986–87: Boise traveling scholarship
1984–85: Hochschule der Künste, Berlin
1982–86: B.A. in fine art, Slade School of Art, University College, London

AWARDS AND PRIZES
2002–05: Arts and Humanities Research Board, Central St. Martin's College of Art and Design
2002: Wellcome Trust Award, London Turner Prize Short List, Tate
2000: Sci–Art, Wellcome Trust, London
Year of the Artist Award, Arts Council of England
1999: Glen Dimplex Award, Irish Museum of Modern Art, Dublin

SELECTED ONE-PERSON EXHIBITIONS
2006
Galerie Lelong, New York

Khalil Sakakini Cultural Centre, Ramallah

2005
CAAM Centro Atlántico de Arte Moderno, Gran Canaria, Spain

Herzliya Museum of Contemporary Art, Israel

Art Basel, Switzerland

Foam Photography Museum, Amsterdam

2004
Alison Jacques Gallery, London

2002
Descent, asprey jacques, London

2001
Star, National Gallery of Modern Art, New Delhi

2000
New Art Gallery, Walsall, England

Synagogue (Art in Sacred Spaces), Congregation of Jacob, London

Cell, i8 Gallery, Reykjavik

SELECTED GROUP EXHIBITIONS
2007
Plug In ICA, Winnipeg, Manitoba, Canada

2005
New Territories, Cultuurcentrum Brugge, Belgium

Art Futures, Contemporary Art Society, Bloomberg SPACE, London

Expo 2005 Nagoya, British Pavilion, Nagoya, Japan

In Progress, Locarno International Film Festival, Switzerland

Seventh Graz Biennial on Media and Architecture, Austria

Thrust, Twenty-Sixth Biennial of Graphic Arts, Ljubljana, Slovenia

Les Grande Spectacles, Museum der Moderne Salzburg

WOW, Henry Art Gallery, University of Washington, Seattle

Interior View: Artists Explore the Language of Architecture, De Zonnehof Centrum voor Moderne Kunst, Amersfoort, The Netherlands

2003
Eastwing Collection 06, Courtauld Institute of Art, London

Up Close and Personal, Nottingham Castle, Drawing with Light International Photography Festival, Nottingham, England

The City That Never Was: Fantastic Architecture in Western Art, Centro de Cultura Contemporania de Barcelona

2002
Cinema India: The Art of Bollywood, Victoria & Albert Museum, London

Tate Modern Collection, Tate Modern, London

2001
Multiplication: Artists' Multiples, Artists Multiplied, National Museum of Art, Bucharest, Romania

Northern Gallery of Contemporary Art, Sunderland, England

2000
Light x 8, The Jewish Museum, New York

Exhibition Checklist

Boaz Arad
(Israeli, b. 1956, lives in Tel Aviv) and
Miki Kratsman (Israeli, b. Argentina
1959, lives in Tel Aviv)
Untitled, 2003
Video installation, 40 min.
Collection of the artists, courtesy
Chelouche Gallery, Tel Aviv

Yael Bartana
(Israeli, b. 1970, lives in Amsterdam
and Tel Aviv)
Trembling Time, 2001
Video installation, soundtrack by
Tao G. Vrhovec Sambolec, 6 min.,
20 sec.
The Israel Museum, Jerusalem; Pur-
chase through Artvision Acquisition
Committee, Israel

Freedom Border, 2003
Video installation, 3 min.
Annet Gelink Gallery,
Amsterdam

Rina Castelnuovo
(Israeli, b. 1956, lives in Jerusalem)
Hilltop Youth, West Bank, Winter 2004
(from the *Settlers* series), 2005
Chromogenic print, 30 × 40 in.
(76.2 × 101.6 cm)
Andrea Meislin Gallery, New York

*Migron Outpost, West Bank, Hanukkah
2004* (from the *Settlers* series), 2005
Chromogenic print, 30 × 40 in.
(76.2 × 101.6 cm)
Andrea Meislin Gallery, New York

Ganei Tul, Gaza, 21 August 2005
Chromogenic print, 30 × 40 in.
(76.2 × 101.6 cm)
Andrea Meislin Gallery, New York

*Netzarim Synagogue, Forced
Evacuation, Gaza, 22 August 2005*
Chromogenic print, 30 × 40 in.
(76.2 × 101.6 cm)
Andrea Meislin Gallery, New York

Rineke Dijkstra
(Dutch, b. 1959, lives in Amsterdam)
*Daniel, Adi, Shira, and Keren, Zeev
Junior High School, Herzliya, Israel,
April 12, 1999*, 1999
Chromogenic print, 51¼ × 59⅞ in.
(130 × 152 cm)
Marian Goodman Gallery, New York

*Daniel, Adi, Shira, and Keren, Rishonim
High School, Herzliya, Israel, December
17, 2000*, 2000
Chromogenic print, 51¼ × 59⅞ in.
(130 × 152 cm)
Marian Goodman Gallery, New York

Abigail, Herzliya, Israel, April 10, 1999,
1999
Chromogenic print, 49⅝ × 42⅛ in
(126 × 107 cm)
The Jewish Museum, New York, Pur-
chase: Melva Bucksbaum Contempo-
rary Art Fund and the Photography
Acquisitions Committee Fund,
2004–60.1

*Abigail, Palmahim Israeli Air Force Base,
December 18, 2000*, 2000
Chromogenic print, 49⅝ × 42½ in.
(126 × 107 cm)
The Jewish Museum, New York, Pur-
chase: Melva Bucksbaum Contempo-
rary Art Fund and the Photography
Acquisitions Committee Fund,
2004–60.2

*Omri, Givati Brigade, Golan Heights,
Israel*, March 29, 2000
Chromogenic print, 70⅞ × 59⅛ in.
(180 × 150 cm)
Herzliya Museum of Contemporary
Art, Tel Aviv

Barry Frydlender
(Israeli, b. 1954, lives in Tel Aviv)
The Blessing, 2005
Digital chromogenic print, 57¾ ×
162½ in. (145.8 × 412.8 cm)
Andrea Meislin Gallery, New York

Ori Gersht
(Israeli, b. 1967, lives in London)
Ghost-Olive No. 1, 2003
Chromogenic print mounted on
aluminum, 40¼ × 33¼ in. (102.2 ×
84.5 cm)
Collection of Thomas H. Lee and
Ann Tenenbaum, New York

Ghost-Olive No. 7, 2003
Chromogenic print mounted on alu-
minum, 40¼ × 33¼ in. (102 × 84.5 cm)
Ruth O'Hara Gallery, New York

Ghost-Olive No. 9, 2003
Chromogenic print mounted on alu-
minum, 41 × 34 in. (104.1 × 86.4 cm)
Collection Judy and Don Rechler,
Locust Valley, New York

Amit Goren
(Israeli, b. 1957, lives in Tel Aviv)
Map, 2003
Six-channel video installation, in
Hebrew, Arabic, English, and Kazakh,
with subtitles; additional camera
work by Eytan Harris, sound design
by Alex Claude, music by Yoav
Goren, 8 min., 28 sec.
Collection of the artist, Tel Aviv

Michal Heiman
(Israeli, b. 1954, lives in Tel Aviv)
Blood Test, 2002
Digital chromogenic print mounted
on aluminum, triptych; each 20½ ×
40⅛ in. (52.1 × 101.6 cm)
Andrea Meislin Gallery, New York

Blood Test, 2002
Digital chromogenic print mounted
on aluminum, triptych; each 20½ ×
40⅛ in. (52.1 × 101.6 cm)
The Jewish Museum, New York,
Purchase: Sylvia Monaghan Bequest,
2003–28.1–3

Noel Jabbour
(Palestinian, b. 1970, lives in Berlin)
Abu Dis Wall, 2004
Digital print mounted on aluminum,
30 × 101 in. (76 × 256 cm)
Loushy Art & Editions, Tel Aviv

Miki Kratsman
(Israeli, b. Argentina 1959, lives in
Tel Aviv)
Kalandia #1, 2001
Chromogenic print, 27 × 39⅜ in.
(68.6 × 100 cm)
Chelouche Gallery, Tel Aviv

*Old Couple in Dahaisha Refugee Camp,
Bethlehem*, 2002
Chromogenic print, 39⅜ × 27½ in.
(100 × 70 cm)
Chelouche Gallery, Tel Aviv

Christian Couple, Bethlehem, 2003
Digital chromogenic print, 39⅜ ×
27½ in. (100 × 70 cm)
Chelouche Gallery, Tel Aviv

Leora Laor
(Israeli, b. 1952, lives in Jerusalem)
Wanderland, 2002–4
Gelatin-silver prints, each 18 × 24 in.
(45.7 × 61 cm)
Andrea Meislin Gallery, New York

Gillian Laub
(American, b. 1975, lives in New York)
Haya and Hanna, Jaffa Israel, 2002
Chromogenic print, 30 × 40 in.
(76.2 × 101.6 cm)
Courtesy of the artist and Bonni
Benrubi Gallery, New York

Mahmoud, Jaffa, Israel, 2002
Chromogenic print, 20 × 24 in.
(50.8 × 61 cm)
Courtesy of the artist and Bonni
Benrubi Gallery, New York

Tal and Moran, May 2002
Chromogenic print, 40 × 30 in.
(101.6 × 76.2 cm)
Courtesy of the artist and Bonni
Benrubi Gallery, New York

Yussie in the Old City, Jerusalem, Israel,
2002
Chromogenic print, 30 × 40 in.
(76.2 × 101.6 cm)
Courtesy of the artist and Bonni
Benrubi Gallery, New York

Guy and Ranit, Arad, Israel, 2003
Chromogenic print, 30 × 40 in.
(76.2 × 101.6 cm)
Courtesy of the artist and Bonni
Benrubi Gallery, New York

Yaron Leshem
(Israeli, b. 1972, lives in New York)
Village, 2004
Digital chromogenic print laminated
on Plexiglas mounted on a light box,
35¾ × 185 in. (91 × 470 cm)
Courtesy of the artist, New York

Motti Mizrachi
(Israeli, b. 1946, lives in Tel Aviv)
Blinking, 2000
Digital print on canvas, triptych;
each 45⅜ × 31½ in. (115 × 80 cm)
Chelouche Gallery, Tel Aviv

Orit Raff
(Israeli, b. 1970, lives in New York
and Tel Aviv)
Untitled (Apron) (from *Insatiable*
series), 2001–4
Chromogenic print, 50 × 40 in.
(127 × 101.6 cm)
Courtesy of the artist and Julie Saul
Gallery, New York

Untitled (Oven) (from *Insatiable*
series), 2001–4
Chromogenic print, 34 × 29 in.
(86.4 × 73.7 cm)
Courtesy of the artist and Julie Saul
Gallery, New York

Guy Raz
(Israeli, b. 1964, lives in Tel Aviv)
Lifeguard Towers—Serial 1, 2003
Chromogenic print, four works;
each 22¼ × 31⅞ in. (56 × 81 cm)
Nelly Aman Gallery, Tel Aviv

Igael Shemtov
(Israeli, b. 1952, lives in Binyamina, Israel)
Landscape with Castor Oil Plant #10, 1999
Chromogenic print, 50 × 59⅛ in. (127 × 150 cm)
The Israel Museum, Jerusalem; Purchase through Marion and Guy Naggar Fund, London

Wolfgang Tillmans
(German, b. 1968, lives in London)
Aufsicht (yellow), 1999
Ink jet print, 102 × 70 in. (259.1 × 177.8 cm)
Andrea Rosen Gallery, New York

still life, Tel Aviv, 1999
Chromogenic print, 20 × 24 in. (50.8 × 61 cm)
Andrea Rosen Gallery, New York

Mark Wallinger
(British, b. 1959, lives in London)
Painting the Divide (Jerusalem), 2005
Digital print on canvas, on two six-panel folding screens, each 94½ × 191 × 17¾ in. (240 × 485 × 45 cm)
Galerie Krinzinger, Vienna

Wim Wenders
(German, b. 1945, lives in Los Angeles and Berlin)
Jerusalem Seen from the Mount of Olives, 2000
Chromogenic print, 114⅛ × 45⅞ in. (289.9 × 116.5 cm)
The Jewish Museum, New York, Purchase: Photography Acquisitions Committee Fund and Alice and Nahum Lainer Gift, 2004–62

Jerusalem Seen from Mount Zion, 2000
Chromogenic print, 114⅛ × 45⅞ in. (289.9 × 116.5 cm)
The Jewish Museum, New York, Purchase: Photography Acquisitions Committee Fund and Alice and Nahum Lainer Gift, 2004–61

Pavel Wolberg
(Israeli, b. Soviet Union 1966, lives in Tel Aviv)
Qalqilya (Outskirts), 2002
Digital chromogenic print, 21½ × 31 in. (54.6 × 78.7 cm)
The Jewish Museum, New York, Purchase: Photography Acquisitions Committee Fund, 2003–29

Qalqilya (Outskirts), 2002
Digital chromogenic print, 19¾ × 27½ in. (50 × 70 cm)
Dvir Gallery, Tel Aviv

Jenin, 2004
Digital chromogenic print, 19¾ × 27½ in. (50 × 70 cm)
Dvir Gallery, Tel Aviv

Israeli Police Confronts the Jewish Demonstrating Settlers During the Evacuation of Mitzpeh Yitzhar, 2004, 2005
Digital chromogenic print, 19¾ × 27½ in. (50 × 70 cm)
Dvir Gallery, Tel Aviv

Kefar Meimon, 2005
Digital chromogenic print, 27½ × 19¾ (70 × 50 cm)
Dvir Gallery, Tel Aviv

Man Walking Through Checkpoint, 2005
Digital chromogenic print, 19¾ × 27½ in. (50 × 70 cm)
Dvir Gallery, Tel Aviv

Sharon Ya'ari
(Israeli, b. 1966, lives in Tel Aviv)
Page 4, 1999
Chromogenic print, 48⅞ × 61¼ in. (124.1 × 156.2 cm)
Lisson Gallery, London

Cypresses, 2001
Chromogenic print, 50¼ × 63 in. (127.5 × 160 cm)
The Jewish Museum, New York, Purchase: William and Jane Schloss Family Foundation Gift, 2006–43

Catherine Yass
(British, b. 1963, lives in London)
Wall, 2004
Video installation, 32 min., 50 sec.
Alison Jacques Gallery, London

Notes

Beyond Boundaries, Within Borders

Epigraph: Edward Said, *Culture and Imperialism* (New York: Alfred A. Knopf, 1993), 7.

1. Edward Said, *Orientalism* (New York: Vintage, 1979), 3.

2. Francis Wey, "Des Progres et de l'Avenir de la Photographie," *La Lumière*, October 5, 1851, 128; quoted in Nissan N. Perez, *Focus East: Early Photography in the Near East, 1839–1885* (New York: Harry N. Abrams, 1988), 102.

3. Eyal Onne, *Photographic Heritage of the Holy Land, 1839–1914* (Manchester: Institute for Advanced Studies, Manchester Polytechnic, 1980), 104.

4. See Irit Rogoff, *Terra Infirma: Geography's Visual Culture* (London: Routledge, 2000). Pointing out that "images are the sites of identity-construction rather than a reflection of the cultural and material conditions of their making," Rogoff analyzes portraits of Israeli women published in the books *Women Build a Land* (New York, 1962) and *Women Who Made History* (Tel Aviv, 1989). Such images, she argues, not only represent the "collective heroics of early Zionist activity in Palestine" but also construct an "Israeli woman" distinct from her European and Oriental counterparts.

5. These visitors included this critic, in 1990.

6. Rogoff, *Terra Infirma,* 155.

A Matter of Place

1. Tartakover's greeting quotes a verse that is preceded by, "For the Lord your G-d is bringing you into a good land, a land with streams and springs and fountains issuing from plain and hill" (Deuteronomy 8:7).

2. *Intifada* is the Arabic word for uprising. The first intifada broke out in December 1987. This intifada was characterized by general strikes, stone-throwing youths, and mass demonstrations, and generated a strong reaction from Israeli security forces. The first intifada is generally considered to have ended with the signing of the Oslo Accords in September 1993. Violence broke out again in October 2000, ostensibly triggered by Ariel Sharon's visit to the Temple Mount in Jerusalem, which is also the site of the Al-Aqsa Mosque. This uprising, known as the Second Intifada or the Al-Aqsa Intifada, has been characterized by gun battles, rocket attacks, and suicide bombings. By 2006 the broad-based intifada had diminished, but acts of violence continued.

3. Sergio Edelsztein, "Israeli Art and the Media in the Last Decade," in Joshua Simon and Sergio Edelsztein, eds., *Blanks* (Tel Aviv: Center for Contemporary Art, 2005), 108.

4. While I was working on this exhibition, a session of the February 2006 College Art Association meeting took place entitled "Feminist Art and Postnationalist Jewish and Arab Identities." This suggests that the Middle East is a significant focus of interest in today's art, as well as in current streams of art history and global politics. The exploration of this subject at an annual convention of art historians is also the measure of a trend in today's art world that inclines toward the expression of "heterogeneous identities" extending beyond any particular nation-state and "embracing a more complex understanding of what postnationalist identities might entail" (abstract of session chaired by Lisa Bloom, University of California, San Diego).

5. See Mark Nash, *Experiments with Truth* (Philadelphia: Fabric Workshop and Museum, 2004), 61–65.

6. The Green Line refers to 1949 Armistice lines established between Israel and its opponents (Lebanon, Syria, Jordan, and Egypt) at the end of the 1948 Arab-Israeli War. The Green Line separates Israel not only from these countries but from territories Israel would later capture in the 1967 Six-Day War, including the West Bank and the Gaza Strip. See Martin Gilbert, *Atlas of the Arab-Israeli Conflict* (New York: Macmillan, 1974), 38.

7. A version of Alÿs's walk-based work was exhibited at the Israel Museum in Jerusalem in September 2005.

8. At no time has Israel been able to live in peace for more than a ten-year stretch: starting with the War of Independence in 1948, it has seen the Sinai Campaign of 1956, the Six-Day War of 1967, the Yom Kippur War of 1973, the Lebanon War of 1982, the first Gulf War

of 1990–91, the intifadas of 1987 and 2000, and the Lebanon War of 2006.

9. Traditionally, the Mount of Olives is revered as the site from which the Redemption of the Dead will begin in the End of the Days (Ketubin 11; Zecharia 14:4).

10. See *Afterglow; Ori Gersht* (London: August; Tel Aviv: Tel Aviv Museum of Art, 2002), 141–42.

11. Loushy, *Igael Shemtov: Low Landscape Low Reality* (Tel Aviv: Loushy Art and Editions, 2004).

12. Yaron Leshem, quoted in *"Mini Israel,"* exh. cat. (Jerusalem: Israel Museum, 2006), 90.

13. See Azoulay, "I Was There," in Ariella Azoulay, *The Civil Contract of Photography,* trans. Ruvik Danieli (Cambridge, Mass.: MIT Press, forthcoming).

14. This artist, as well as some other Arab-Israeli artists, declined to participate in this exhibition, presumably because her involvement would be construed as an endorsement of official policies toward the occupation.

15. Judy Bullington, abstract for "Imagining Placescapes in Palestinian Art," from Feminist Art and Postnationalist Jewish and Arab Identities panel, College Art Association 94th Annual Conference, February 2006.

16. Nissan N. Perez, *Condition Report: Photography in Israel Today* (Jerusalem: Israel Museum, 1997). The exhibition *Critically Correct* at the Givon Art Gallery in Tel Aviv in 2004 brought together artworks that took a critical stance toward Israeli society.

17. In Israel, according to the curators Eyal Danon and Galit Eilat, video art was introduced into the museum, and later into the gallery, with the mid-1960s development of the Sony Portapak, the first portable device for video recording. Until then, video was confined to the television studio. See Eyal Danon and Galit Eilat, "Story Agent: Digital ArtLab, Holon," *Video Zone,* exhibition catalogue for the *First International Video-Art Biennial in Israel,* November 20–26, 2002.

18. Twice a year special sirens are heard all over Israel summoning citizens to remember: on the Day of Remembrance for the Holocaust (Yom Ha-Shoah) and on the Day of Remembrance for fallen soldiers and victims of terror (Yom Ha-Zikaron). This ceremony was adopted in 1959, eleven years after the founding of the State of Israel. During a period of silence, all public life in the country comes to a standstill: cars stop in their tracks and pedestrians come to a halt.

19. The artist has said, "State-organized memorials, ceremonies, and military events define tradition and shape national identity. They are powerful and therefore dangerous phenomena that perpetuate patterns of loyalty and ignorance. I am interested in the dynamics of the state that prescribes a belief system, and the individual who embraces it." See Yael Bartana's statement on the Manifesta 4 website,

http://www.manifesta.org/manifesta4/en/projects/artist1354.html.

20. Traditionally, Israel has regarded the military as a flawless organization, a melting pot in which the different diasporic cultures fuse together. This view has been steadily eroding since the Lebanon War in 1982—a war that, for the first time, made political use of the army and inspired the first conscientious objectors to military service.

21. The outbreak in 2000 of the Al-Aqsa Intifada and a rising number of attacks by Palestinian suicide bombers prompted Israelis to strengthen their methods to protect themselves. Among other responses was a plan to build a defensive barrier that would separate Israel from the West Bank and the Gaza Strip. A temporary wall was erected in Gaza; it was followed by an Israeli government decision in June 2002 to put up a 450-mile barrier meant to safeguard Israel against incursions from the West Bank. It was accepted by most Jewish citizens as a necessary measure for self-preservation, but Palestinian critics and others cite it as a "walling in" of the Palestinians.

22. Meron Benvenisti, former deputy mayor of Jerusalem, quoted in Nicolai Ouroussoff, "A Line in the Sand," *New York Times,* January 1, 2006.

23. Catherine Yass and Rosalind Nashashibi, "Having a Take," *Bidoun,* no. 2 (Fall 2004). See also Andrew Renton, "Walking Through Wall: Catherine Yass's Politics of Unseeing," in *Catherine*

Yass: Filmography (Gran Canaria, Canary Islands: Centro Atlántico de Arte Moderno, 2005), 72–89.

24. Statement written by the artist for The Jewish Museum, September 24, 2005.

25. Abu Dis is considered part of Israel; some of Jerusalem's municipal boundaries extend beyond the Green Line.

26. Artist's statement, September 24, 2005.

27. Wim Melis, ed., *Nazar: Photographs from the Arab World* (New York: Aperture, 2004), 240.

28. See Sergio Edelsztein, "Israeli Art and the Media in the Last Decade," in Joshua Simon and Sergio Edelsztein, eds., *Blanks* (Tel Aviv: Center for Contemporary Art, 2005), 104.

29. Margaret O'Connor, quoted in Michele Chabin, "Trouble at Home," *PDN,* May 2003, 30.

30. "I work hard to create seamless images, but there are always some hints left so the viewer can see it's been worked on." Barry Frydlender, quoted in *Rencontres de la photographie Arles 2005* (Arles: Actes Sud, 2005), 98.

31. Gillian Laub, "Common Ground," in ibid., 78.

32. Ibid.

33. See Yaron Ezrahi, *Rubber Bullets: Power and Conscience in Modern Israel* (New York: Farrar, Straus, and Giroux, 1997), 254.

34. The prominence of military themes in lens-based art in Israel is understandable because men are required to serve in the armed forces for three years and women for two. Men can be called to serve in the reserves until the age of forty, whereas women are exempt from the reserves at the age of thirty-eight (earlier if they are pregnant).

Selected Bibliography

Azoulay, Ariella. *The Angel of History*. Exh. cat. Herzliya, Israel: Herzliya Museum of Art, 2000.

———. *Death's Showcase: The Power of Image in Contemporary Democracy*. Cambridge, Mass.: MIT Press, 2001.

Cassouto, Nella, and Robert Stearns. *Aspirations: Toward a Future in the Middle East*. Exh. cat. Columbus, Ohio: Ohio Arts Council's Riffe Gallery, 2001.

Chilufim: Exchange of Artists and Art. Exh. cat. Jerusalem: Israel Museum; Herzliya, Israel: Herzliya Museum of Art; Bonn: Kunstmuseum Bonn; Krefeld: Kaiser Wilhelm Museum; Dortmund: Museum am Ostwall, 2002.

A Delicate Balance: Six Israeli Photographers. Exh. cat. Charlotte, N.C.: Light Factory, 1996.

Edlinger, Thomas, Stella Rollig, and Roland Schöny. *The Promise, the Land: Jewish-Israeli Artists in Relation to Politics and Society*. Linz: O.K. Center for Contemporary Art, Upper Austria, 2003.

Faccin, Severino, ed. *Dreams and Conflicts: The Viewer's Dictatorship*. Exh. cat. (Venice Biennale). New York: Rizzoli, 2003.

Goodman, Susan Tumarkin, ed. *After Rabin: New Art from Israel*. Exh. cat. New York: The Jewish Museum, 1998.

Hon, Gordon, ed. *What Remains To Be Seen: Art and Political Conflict: Views from Britain, Israel, Palestine, and Northern Ireland*. London: Multi-Exposure, 2004.

Kleeblatt, Norman L. "Israel's Traumas and Dreams." *Art in America* (May 2006): 106–15.

Lavoie, Vincent. *Now: Images of Present Time*. Montreal: Le Mois de la Photo à Montréal, 2003.

Levitte Harten, Doreet, ed. *Die Neuen Hebräer: 100 Jahre Kunst in Israel* (The New Hebrews: 100 Years of Israeli Culture). Exh. cat. Berlin: Martin-Gropius-Bau and Nicolai, 2005. In German.

Melis, Wim. *Nazar: Photographs from the Arab World*. New York: Aperture, 2005.

North Carolina to Israel Photographic Project. Asheville, N.C.: Asheville Art Museum; Charlotte, N.C.: Light Factory, 1997.

Omer, Mordechai, ed. *Contemporary Israeli Photography: Three Generations*. Tel Aviv: Tel Aviv Museum of Art, 2003.

Perez, Nissan N. *Condition Report: Photography in Israel Today*. Exh. cat. (CD-Rom). Jerusalem: Israel Museum, 1998.

———. *Revelation: Representations of Christ in Photography*. Exh. cat. Jerusalem: Israel Museum; London: Merrell, 2003.

———. *Time Frame: A Century of Photography in the Land of Israel*. Exh. cat. Jerusalem: Israel Museum, 2000.

Raz, Guy, ed. *Photographers of Palestine Eretz Israel/Israel, 1855–2000*. Tel Aviv: MAP & Hakibbutz Hameuchad, 2003. In Hebrew.

Rencontres de la Photographie Arles 2005. Arles. Actes Sud, 2005.

Segal, Rafi, and Eyal Weizman, eds. *A Civilian Occupation: The Politics of Israeli Architecture*. Exh. cat. Tel Aviv: Babel; London: Verso, 2003.

Shapira, Sarit. *Not To Be Looked At: Unseen Sites in Israel Today*. Exh. cat. Jerusalem: Israel Museum, 2000.

Simon, Joshua, and Sergio Edelsztein, eds. *Blanks*. Tel Aviv: Center for Contemporary Art, 2005.

Slome, Manon. *Such Things as Dreams Are Made On: An Exhibition of Contemporary Israeli Art*. Exh. cat. New York: Chelsea Art Museum, 2005.

Squiers, Carol, ed. *Over Exposed: Essays on Contemporary Photography*. Exh. cat. New York: New Press, 1999.

Tenenbaum, Ilana, ed. *Video One: Body–Screen–Digitalia*. Exh. cat. Haifa: Haifa Museum of Art, 2001.

Weibel, Peter, and Günther Holler-Schuster, eds. *M ARS: Kunst und Krieg*. Exh. cat. Graz: Neue Galerie am Landesmuseum Joanneum; Ostfildern: Hatje Crantz, 2005.

Wherever I Am: Yael Bartana, Emily Jacir, Lee Miller. Essays by Galit Eilat, Linda Grant, David Alan Mellor, Edward Said, and Tom Vanderbilt. Exh. cat. Oxford: Modern Art Oxford, 2004.

Zerubavel, Yael, Tami Katz-Freiman, and Amy Cappellazzo. *Desert Cliché: Israel Now—Local Images*. Exh. cat. Miami Beach: Bass Museum of Art, 1996.

Contributors

Susan Tumarkin Goodman is senior curator at The Jewish Museum, where she has organized numerous exhibitions and written and edited many catalogues. On the subject of Israeli art, her books include *After Rabin: New Art from Israel* (1998), *In the Shadow of Conflict: Israeli Art, 1980–1989* (1989), *A World of Their Own: Naive Artists from Israel* (1987), and *Artists of Israel, 1920–1980* (1981). Her exhibition catalogues on Russian art include *Marc Chagall: Early Works from Russian Collections* (2001), *A Witness to History: Yevgeny Khaldei, Soviet Photojournalist* (1997), and *Russian Jewish Artists in a Century of Change, 1890–1990* (1995). Among her other publications are *The Emergence of Jewish Artists in Nineteenth-Century Europe* (2001) and *From the Inside Out: Eight Contemporary Artists* (1993).

Andy Grundberg is the chair of photography at the Corcoran College of Art and Design in Washington, D.C., and the author of *The Land Through a Lens: Highlights from the Smithsonian American Art Museum* (2003), *Mike and Doug Starn* (1990), and *Alexey Brodovitch* (1989). A selection of his articles for the *New York Times* and other publications is collected in *Crisis of the Real: Writings on Photography Since 1974* (1999). He organized the exhibition *In Response to Place: Photographs from the Nature Conservancy's Last Great Places* (2001), which opened at the Corcoran Gallery of Art and toured nationally until 2005. As head of The Friends of Photography in San Francisco from 1992 to 1996, he was editor and publisher of *see: A Journal of Visual Culture* and served as director of the Ansel Adams Center for Photography.

Nissan N. Perez is Horace and Grace Goldsmith Senior Curator of the Noel and Harriette Levine Department of Photography at the Israel Museum in Jerusalem, where he has conceived and organized many exhibitions, including *Camera Sacra: Capturing the Soul of Nature* (2005), *Pioneers of Photography in Israel* (2003), *Revelation: Representations of Christ in Photography* (2003), *Weegee's Story: A Photojournalist in the 1940s* (2002), and *Condition Report: Photography in Israel Today* (1998). At the Contemporary Jewish Museum in San Francisco, he was curator of *Art of Living: Contemporary Photography and Video from the Israel Museum* (2006). Among the numerous books he has written in English and in Hebrew are *Revelation: Representations of Christ in Photography* (2003), *Focus East: Early Photography in the Near East, 1839–1885* (1988), and *Dreams, Visions, Metaphors: The Photographs of Manuel Alvarez Bravo* (1983).

Index

Note: Page numbers in **boldface** refer to illustrations.

Illustration Credits

Boldface numerals refer to page numbers. Unless otherwise indicated, copyright for all artworks reproduced in this volume is held solely by their creators.

Cover: (front) © Wolfgang Tillmans, image courtesy Andrea Rosen Gallery, New York

Grundberg Essay: 6 Image © 2006 Christie's Images, Inc. 4 © Bernd and Hilla Becher, photo by David Heald © The Solomon R. Guggenheim Foundation, New York. 7 © Estate Helmar Lerski, Museum Folkwang, Essen. 9 © 2006 Michal Rovner/Artists Rights Society (ARS), New York, Photograph © 1993 The Metropolitan Museum of Art (left), image courtesy Postmasters Gallery, New York (right). 12 © Rina Castelnuovo/Courtesy Andrea Meislin Gallery, New York. 14 © 2007 Thomas Struth/Courtesy Marian Goodman Gallery, New York, photo by David Heald © The Solomon R. Guggenheim Foundation, New York. 16–17 © Barry Frydlender/Courtesy Andrea Meislin Gallery, New York.

Goodman Essay: 28 © Michal Heiman/Courtesy Andrea Meislin Gallery, New York. 29 Photo by Bill Orcutt (top). 33 © Rina Castelnuovo/Courtesy Andrea Meislin Gallery, New York. 38–39 © Wolfgang Tillmans, images courtesy Andrea Rosen Gallery, New York.

Plates: 41 © Wolfgang Tillmans, image courtesy Andrea Rosen Gallery, New York. 67 © Rina Castelnuovo/Courtesy Andrea Meislin Gallery, New York. 70–71 © Barry Frydlender/Courtesy Andrea Meislin Gallery, New York. 74 © Leora Laor/Courtesy Andrea Meislin Gallery, New York.

Artist Biographies: 81 Photo: Elon Ganor (right). 85 Photo: Yair Barak (left).